REDNOCK SCHOOL

FROM ITS BEGINNINGS TO BEING GLOUCESTERSHIRE'S ONLY PATHFINDER SCHOOL

COMPILED BY
BARBARA SKAL & DAVID EVANS

AMBERLEY

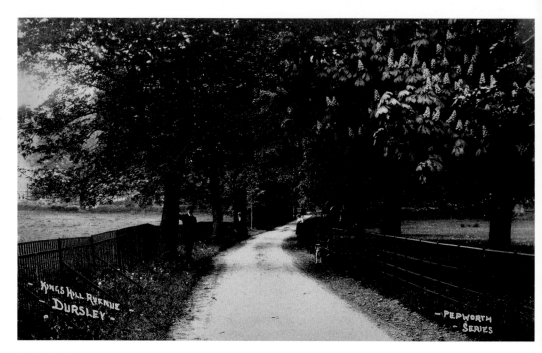

Rednock Drive *c.* 1910.

First published 2009

Amberley Publishing Plc
Cirencester Road, Chalford,
Stroud, Gloucestershire, GL6 8PE

www.amberley-books.com

British Library Cataloguing in Publication Data.
A catalogue record for this book is available from the British Library.

ISBN 978 1 84868 879 7

Typesetting and Origination by Amberley Publishing.
Printed in Great Britain.

CONTENTS

ACKNOWLEDGEMENTS

Many people have been involved in producing this volume. Some have provided memories of their times at Rednock or the preceding secondary schools, and it has been with great regret that we have been unable to include all of these, nor quote in entirety the few printed here. Nevertheless, *all* contributions are valued and will go into the school's archives for possible future use. (If this modest book stirs more memories, the school would very much like to receive these too.) In whatever way the following have contributed to this book, the school acknowledges them with great pleasure:

John Pritchard – headteacher 1988-2004; Huw Williams – retired in 2003 as assistant headteacher, after teaching on the Rednock site for over 35 years; John Swann – retired in 2001 after 26 years as deputy headteacher; Derek Browning, Andrew Barton, Rachel Finch, Denis Lewis, Jose French, Joan White, Eva Griffey, T. G. Bloodworth, Denise Billings, John Cox, Jenny Evered, Mervyn Phillips, Valerie Rodway, Janet Coombe, Mandy Clutterbuck, David Bennett, Helen Baines, Heather Targett, Christine Reeves, Alan Guy, David Ashbee, Ian Wilkins, Otto Mellerup, Barbara and John Grove, Richard Wintle, Geoff Moyser, Christopher Prout, Cynthia Veale, Chris Steer, David Martin, Andrew Pinch, Penny Edwards née Price, Susan Morgan née Manning, Barbara Morgan, Harriet Niblett, and the editor of the *Gloucestershire Gazette* for permission to reproduce pictures from past editions of the newspaper.

Most pictures used in this book were produced in-house. Of those not, we have – as far as was possible – given credit to the owner/photographer. If we have failed in some cases, we would like to hear – and apologise in advance. Every effort has been made to comply with current legislation regarding publication of student photographs.

Please note that the numbering of years in school has changed. Formerly, pupils entering a secondary school were designated as being in 'Year One'. Now they are said to be in 'Year 7' and so up the school to 'Year 13'.

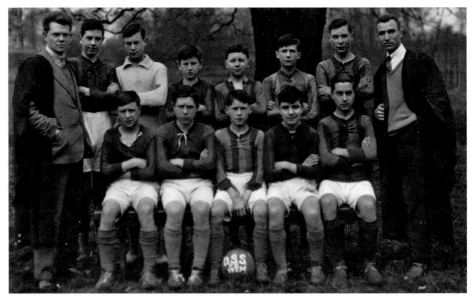

The Dursley Secondary School football team on the Rednock site in 1928, with 'Joe' West on the far right. Mr West was a long-serving and much respected senior master. His nickname in the 1930s and '40s was 'Dusty' but by the 1960s he had become 'Joe'.

FOREWORD

When I became Head of Rednock School, it was a dream come true. I had gone for the interview in March 2004, not expecting to get past the first day, let alone all three days of interviews and tests and then be successful!

I should have known from the start that the buildings at Rednock would play a significant role when I was called in over the summer holidays before I had even started. The drains needed replacing... Little did I know then that it would lead to the new Rednock School re-establishing itself in an iconic building.

When I was interviewed, I made it clear that improving the buildings was a major priority, given that teaching and learning took place in 'temporary' classrooms, which looked long past their sell-by date.

Over the past five years, we have worked long and hard to get to a position where we are working in a new school building. We even appeared on television, when rain came in through a roof! After several unsuccessful bids, we were fortunate enough to be named Gloucestershire's Pathfinder School. Work began in November 2006, consulting with students, staff, governors and the local community about the shape and design of the new school. The advent of a new school made me think that we ought to acknowledge our debt of thanks to the past. All those students, staff, governors and parents who experienced the 'old Rednock' need to be remembered. What better way than a book consisting of memories and photographs which tell something of their story and which also gives a picture of school life as it is today.

I would like to personally thank Barbara Skal, whose hard work and dedication has brought this book to fruition, and David Evans, whose words have enhanced it.

David Alexander
October 2009

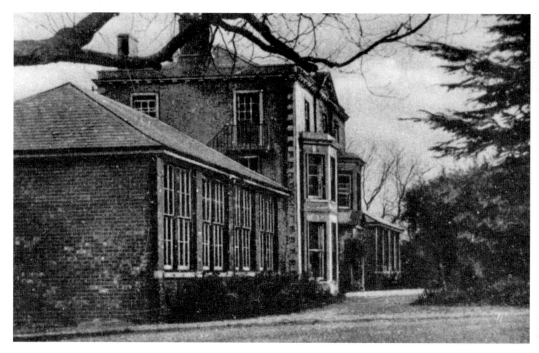

Dursley Secondary School *c.* 1930. The main building, Rednock House was built in the early nineteenth-century and became a school in 1921. The wings were added later and further extended to the west in the late 1940s and then further still in 1964.

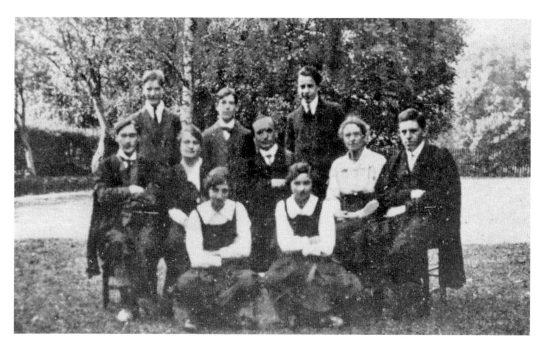

Staff and prefects of the new Secondary School soon after it opened in 1921. Besides Ernest Barratt, headmaster, seen here centre, there were four teachers; Mr John, Mr Worthington, Miss Pick and Mrs Barrett.

INTRODUCTION

Rednock School did not just happen. No fairy godmother waved a wand and planted the school suddenly on the green fields of Rednock. The school we have today has come about because, as education nationally evolved over many centuries, it was tweaked by local conditions. Thus this book on Rednock Comprehensive School begins with a short look at secondary education in Dursley.

Education has a long history in Dursley. For children of what we would now call primary school age, it is possible to trace the beginnings of class teaching, as against individual tutoring, back some 300 years. Secondary education in the area began in 1840, with the founding of the privately run, and highly regarded, Dursley Agricultural and Commercial Grammar School, which operated in Woodmancote until 1904. The national Board of Education then became concerned about the lack of secondary opportunities in Dursley, and in 1904, it proposed that the endowments of the former Twemlow Charity School in Water Street and of Woodmancote Grammar School should be used to help support a new mixed school in the town. It further suggested that the endowment of Cam Hopton Charity School, by then supported by the state, should be used to provide scholarships to the new school. However, being a secondary school, the new one could not be state supported and costs would have to come from the household rates. This the Rural District Council would not sanction and the scheme died.

A Brief History of the Rednock Estate

For many centuries, the lands we now know as Rednock, formerly Ten Acres or Oaklands, were owned by the lord of the manor of Dursley. By 1790, this was Thomas Estcourt of Shipton Moyne and the family who built Dursley's town hall. In 1790, Estcourt sold most of his Dursley holdings. Richard Harris bought Oaklands, together with an important woollen cloth mill in the valley below and lands which are now covered by the town's recreation ground, main car park and swimming pool.

It would seem that Richard, or one of his descendents, built the house at Oaklands. A date of about 1840 has been suggested for this by Percy Woodland. By 1851, the Harris family had left the area, for by then, the house was let to Edward Freeman, an expert in Saxon and Norman history who later became Professor of Modern History at Oxford. E. P. Shute, a shareholder in the Gloucester Plough Company, was occupying the house in 1859. In 1865, the Oaklands estate was sold. Buyer of the house and some lands was Capt George Graham, late of the army in India.

Capt Graham changed the name of the house to Rednock, perhaps associating it with the place believed to be his ancestral home in Scotland. He became an important member of the Dursley community, but his chief claim to fame comes through his great interest in

Irish Wolfhounds. He bred these dogs at Rednock and is credited with saving the breed from extinction.

George Graham died in October 1909. Rednock House and immediate grounds were bought by Sir Ashton Lister, and during the years of the First World War, these were let to Mr H. St Hill Mawdsley, founder of the once-important electrical company of Mawdsleys Ltd on the Uley Road. In 1921, as we will see, Rednock House became the focus of the new Dursley Secondary School.

Dursley Secondary/Grammar School

In 1918, Parliament, through county councils, took responsibility for secondary education. This resulted in a number of Gloucestershire towns agitating for such schools. One was Dursley, with Sir Ashton Lister giving major support. The county council was not averse to providing a school and proposed, in 1919, to build one in wood – brick would be too expensive – near River's Mill on the Uley Road. Later, the site was changed to Kingshill Road, but in 1920, the idea of a new building was abandoned in favour of adapting an existing large house. At that time, Rednock House was empty. In December 1920, it was bought by the county council from Sir Ashton Lister for £5,800 and then converted into a school, but only for boys. Including girls would increase costs!

It was planned that Dursley Secondary School would open in September 1921 with 70 pupils selected by examination. Fees would be £11 pa for pupils over 12 years and £9 pa for those between 8 and 12. Exceptions would be the free places given to scholarship children. In the event, the first intake was 87 pupils and included girls.

The first headteacher was Ernest Barrett, BSc (Chemistry), AIC, FCS, and he began the school with four assistants – Miss Pick, Mrs Barrett, Mr John and Mr Worthington. The last left in 1924 to be replaced by Mr West. The youngest children, aged 8 to 10, led a separate existence, as a preparatory school, in the schoolroom of Cam Meeting Chapel in Upper Cam until 1945.

The numbers of children grew year by year reaching 159 in 1929. Rednock House was too small to accommodate these, and two wings were added to the house to provide four classrooms. A wooden assembly hall, which doubled as a gymnasium, was also built. Also in wood were constructed an engineering science laboratory and rooms for handicrafts and domestic science. The two brick wings and all four of the wooden structures were retained for use in the early days of Rednock School.

In September 1944, Ernest Barrett, a much loved and respected man, died suddenly. His place was taken by Percy Woodland, MA, who came from the public school in Bedford. March 1947 saw the school change its name from Secondary to Grammar in readiness for the opening of Dursley Secondary Modern School.

After four years of hard work in raising money by the Parent Teacher Association of the Grammar School, a school swimming pool was opened in 1959. This served pupils well until the late 1970s, when it was discovered that the pool was beginning to slip down the slope on which it was built. The end came soon after, when it was vandalised one evening by intruders.

In 1962, the Norman Hill Estate came up for sale. It was considered to be a good place on which to build a new school to replace the patchwork of buildings that was the Grammar School. This plan was overtaken by the idea of a college for Dursley, which itself disappeared when plans were put forward in 1965 for the total re-organisation of secondary education in the town.

Percy Woodland retired in 1969. As it was planned to open Rednock Comprehensive School in 1971, John Broomfield was appointed acting headteacher for the remaining two years of the Grammar School. John had served in World War Two as an intelligence officer, and at its end, he joined Dursley Secondary School as a teacher of modern languages. He rose to be head of department, then deputy head of the school. He retired from teaching in 1975.

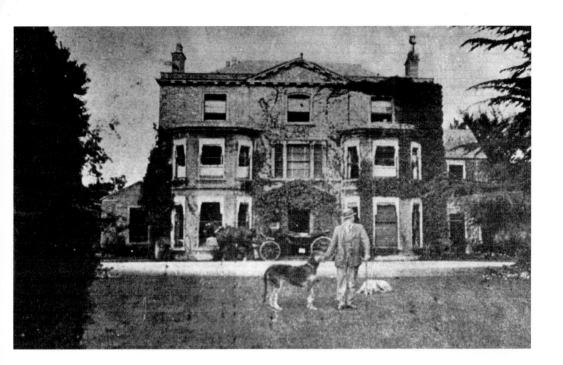

Above: Captain Graham standing in front of Rednock House with an Irish Wolfhound, *c.* 1900.

Right: Dursley Secondary School prefects stand outside Rednock House in 1924. Note the children working in what, perhaps, had been the family drawing room when the house had been in private hands.

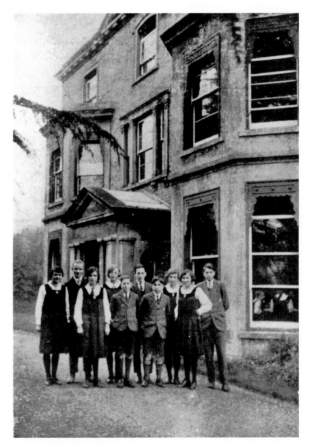

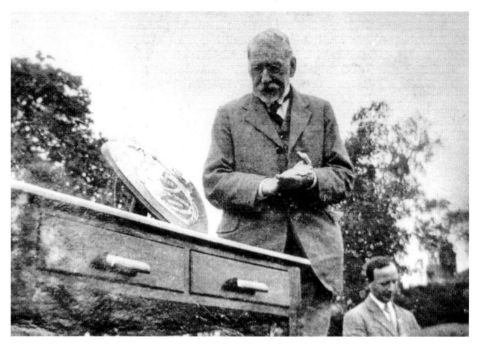

Sir Ashton Lister presenting prizes at the Secondary School's sports day in 1925. Behind him, seated, is Ernest Barrett.

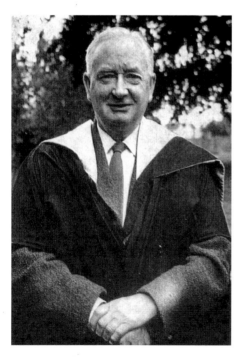

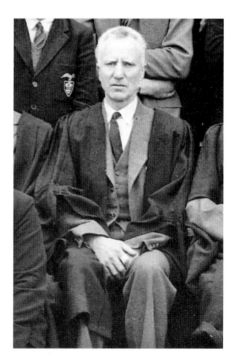

Above left: Percy Woodland, MA.

Above right: Mr West, taken from the School photograph of 1962.

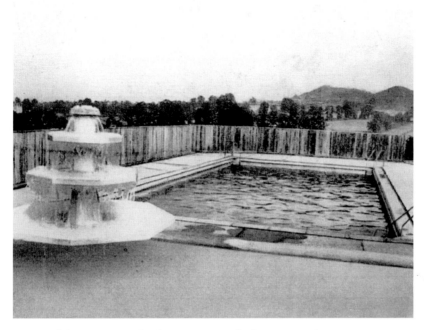

A view of the Grammar School swimming pool when it opened in 1959.

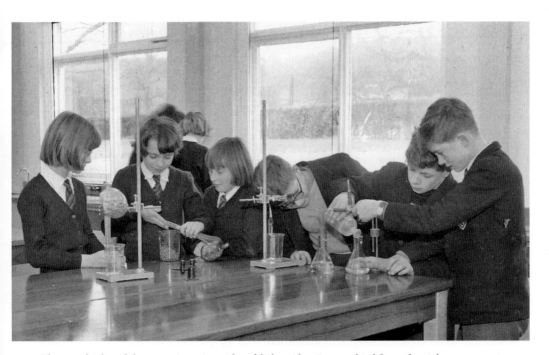

The new biology laboratory in 1964, with publisher Alan Sutton third from the right.

Eva Griffey, née Workman, one of a family connected with the school on the Rednock site from 1923 into the 1970s, was at Dursley Secondary School from 1931 to 1937. Eva has written:

So many memories – the classrooms, the desks where I sat, Mr Barrett, the headmaster, members of staff (some I liked, some not so much), Sports Days, Christmas parties and concerts in the school hall, hockey and tennis matches, but above all the many, many friends I made... It is sad that the 'Old School' must go, but looking to the future, I wish well to all those children, with so many more advantages, who will continue to get their education at the New Rednock.

Joan White, née Burton, attended Dursley Secondary School during the war years, from 1942 to 1946. When in class 5A (would now be year 11), her form teacher was Miss Strang and her form room was on the first floor of the old house, opposite the school library. She, too, remembers many of the teachers, including Captain Broomfield, as he was known. Joan recalls:

In my first year we had to sew a cookery apron, which I still have, before we could do any cooking. We were told always to put the pastry boards one inch from the edge of the table which I still do! I remember the (wartime) school dinners, stew with jacket potatoes, salad with cold baked beans in the bottom of the dish, semolina pudding with babies' orange juice on it. Each table would take it in turns to go up for seconds...

Mr T. G. Bloodworth's time at Dursley Secondary School ran from 1946 to 1950. He has put his memories down as a poem. Unfortunately, space does not allow it to be printed in full, but here is how it begins:

> I went to Dursley Grammar School,
> So many years ago.
> Here's some recollections,
> As my Pen begins to Flow...
> Some teachers I remember
> For example – Mr West.
> He taught us mathematics
> But I rarely passed the Test.
> Mr John was Head of English,
> A gentleman I'd say,
> But picked you up quite smartly
> Should your attention stray...

John Cox (currently Chair of the Site and Building Committee for Rednock School) looked back on his days at the Grammar School with pleasure, though sometimes it had its downside; like being caned for talking while waiting for lunch. Such events were then accepted as part of being at school, like the strictly enforced curfew designed to ensure that pupils were not out and about after 9 in the evenings, or being punished for being caught eating in the streets.

John remembers the gowns teachers wore in lessons and all the sporting activities. Saturday cricket matches were regularly interrupted by people walking their dogs across the school playing fields. (Closing this footpath across the grounds caused great controversy in the early days of Rednock School.) 'There was "music man" Mr Goodman (Benny of course) who taught his lessons in the main hall/gymnasium. Invariably someone spent it inside the vaulting box, either voluntarily or forcibly. Then there was attractive Miss Harry who taught the senior boys to dance with her in such close body contact that would be frowned on today...' and so much more that space does not permit to be recounted here.

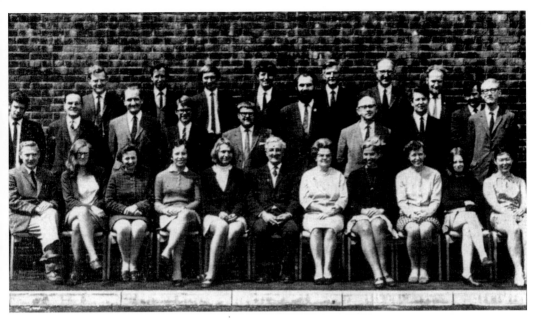

The staff of Dursley Grammar School in May 1971. Back row: Nelson Caplin, Roger Ransome, Harry Myett, Mike Lewis, ?, John Buckingham, John Ewer, Ellis Williams. Centre: Huw Williams, Ron Wilson, David Rowe, ?, Les Rhodes, Lance Peters, Ossie Halliwell, Clifford Cook, Rod Summers. Front: Richard Harvey, Deidre Grunsell, Peggy Tresise, ?, ?, John Broomfield (Acting Headmaster), Mona McPherson (Senior Mistress), Thurza Coleman, ?, ?, ?.

Dursley Secondary Modern School

In the 1920s, a Government enquiry into secondary education produced the Hadow Report of 1926. This recommended that all children above the age of 11 or 12 should be educated apart from younger children by transferring them to senior schools or by making special provision for them at their elementary schools. It also recommended that the school leaving age be raised to 15.

The increasing population of Dursley put pressure on the county council to take all this seriously, but the economic crisis of the early 1930s stopped progress. Building work on a new school at Highfields had to wait until the late 1930s but construction ceased when fighting began at the beginning of World War Two.

The 1944 Education Act put into force the recommendations of the Hadow Report. The school leaving age was to rise to 15 in 1947. All-age elementary schools were to be abolished. In the future, all children would sit an examination in English and Mathematics at the age of 11. The 'eleven plus' came into being. Those that passed would go to a grammar school. Those who did not would go to a secondary modern school.

In 1947, building work recommenced at Highfields and the school was completed at a cost of £70,000. John Peet, BSc, (JEB, as he was affectionately known from his initials) was appointed headteacher. He came from the City of Birmingham Teacher Training College where he had been a tutor in Mathematics, Science, and Visual Methods.

On 18 January 1949, Dursley Secondary Modern School opened its doors to pupils from Slimbridge, Stinchcombe, Cam, Dursley, Coaley and Uley. The school began with a full complement of years 1-5. Some were already aged 15 and stayed only the few months until they left at Easter, as pupils then were allowed to do. A report of the time described the coming Dursley Modern School:

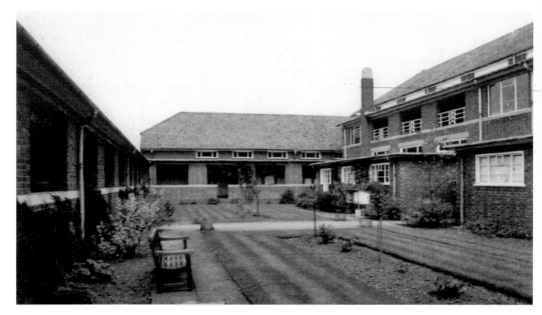

The courtyard of the Modern School, now Dursley Primary School. When built, all of the corridors were open to the elements. Delightful on warm summer days, 'bracing' in winter! The low structure, centre right, housed a small flat for use in housecraft lessons. At the far end of the courtyard is the school hall.

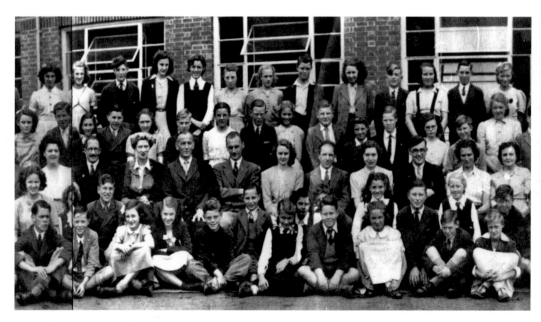

Some of the Modern School staff (centre row) and pupils in 1949. From the left, teachers are: ?, Mr Hunter, Miss Lewis Thomas (Senior Mistress), Mr JEB Peet (headmaster), Mr Dawson, ?, Mr Tremaine, Miss Davies, Mr Walters, Miss Smith and Mrs Pearce. Some children have been identified. Back row, from left: 6th Dianne Sewell, 10th Heather Price. Second row, from front: 1st from left Elaine Price, 3rd Ted Fowler, 5th Rosemary Hathaway, 7th Barbara Edge, 8th Rex Hale, 9th Valerie Rodway. Front row: extreme right, Mavis Palser.

With modernity as the keynote of building and teaching alike, the school will open for scholars vast new fields of interest and provide them with every modern facility never even dreamt of by their parents nor they themselves... every facility seems to have been provided to encourage, bring out and accentuate the creative instincts of the boys and girls.

In July 1949, the school was opened by the Rt Hon George Tomlinson, MP, Minister of Education. With a dedicated staff around him, John Peet fashioned a well-disciplined school with high academic aspirations, one that soon gained tremendous respect in the community. Many ex-pupils look back on their days there with pride. That said, nothing could dispel the feeling of some children that, because they had not cleared the hurdle of the 'eleven plus', they were failures. Some carried that feeling through adulthood, even though in later life they achieved great things. The feeling was probably not helped by the deep separation that existed between Grammar and Modern School pupils. There was a perception that the Grammar School was not interested in events that could bring the children of both together. This, perhaps, is surprising, as the two schools had a joint body of governors.

At one governors' meeting at Highfields, John Peet produced details of a swimming pool built by parents for a school in Dorset. A visit to Dorset provided the impetus for a similar pool at Highfields. After hard work and much money raised by parents, this opened in 1955. Alan Guy has many memories of the school:

The Modern School must have been the envy of others in the district because it had a well-equipped stage where school plays and musicals were performed before audiences of proud parents. It also had a small flat with dining room, bedroom and lavatory where the girls learned housecraft. There they entertained adults and sometimes stayed overnight. On the opposite side of the corridor was the domestic science room with several kitchens complete with cookers and all the equipment needed to teach girls how to cook and become good housewives and mothers. Another splendid feature of the school was the magnificent gymnasium where no-one was allowed to enter without removing their outdoor shoes. We had great fun under John Morris learning how to vault and turn somersaults – all of us, even the most corpulent.

After school, there were clubs galore where you could follow your interests in French, Science, Gymnastics, Film Making, Young Farmers and so on. For those pupils who stepped out of line, there was the punishment of a visit to the Head in his study for a telling off or the ultimate sanction – the cane – which was used rarely. It was the school's ultimate deterrent.

The school was flexible in its approach which was how I came to be taught shorthand and typing by the secretary, Mrs Win Pearce. As a result, when I left and sought a job in journalism, I was about the only candidate at an interview who could write shorthand and type. (These memories of Alan's were first printed in 'Celebrating Cam & Dursley Project 2006-7; Working Lives' and are reproduced by courtesy of Shirley Hill and Louise Amato.)

Valerie Rodway, at the Modern School 1949-1954, also has happy memories of it:

Mr Peet, the headmaster, was strict but very fair. He was a man of high integrity [and...] he did much for me as a pupil and in helping me into my chosen career.

In the early years of the school, a merit system operated where pupils could earn red or black marks depending on behaviour, schoolwork and attitude. At the end of a period, a Friday afternoon was designated for optional activities and those pupils with more red marks than black were allowed to choose one of many activities. If you had more black marks than red, you just carried on with normal lessons. I usually chose the nature walks and well remember that, on one occasion, I fell and cut my leg badly. Mr Tremaine, the teacher in charge of our group, carried me all the way back to school!

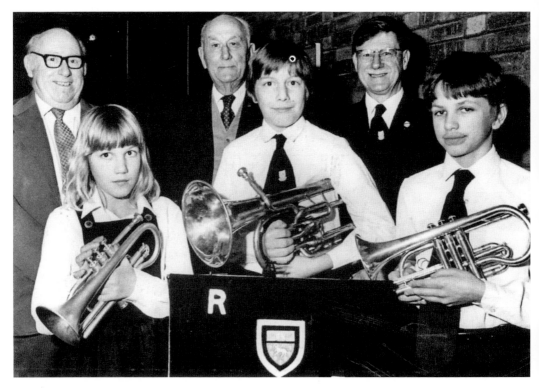

In 1985, the Modern/Rednock Band celebrated its twentieth anniversary by giving a concert in the hall in which it had started, now part of Dursley Primary School at Highfields. Back row: Dick Rodway, school caretaker and a great friend of the pupils of the school; John Peet, the only headmaster of the Modern School, and John Morris, musician extraordinaire – all of whom had played important roles in founding the band. Front row: Lucy Withington, Paul Salmon and Toby Ounstead, who were members of the band in 1985, which had in that year some eighty players divided between senior, training and beginners sections. (Photo: Dursley *Gazette*)

The Modern/Rednock School Band

Early in 1964, four brass players from the Bournemouth Symphony Orchestra played to students and staff at Dursley Modern School. On the staff was PE teacher John Morris who played the trombone, and he voiced the opinion that playing a brass instrument was a worthwhile activity for young people. This was picked up by John Peet who quickly found the money for the purchase of three old, but serviceable, cornets. Negotiations with Stinchcombe Silver Band brought forth other instruments on loan.

With nine players, including John himself, and Edward Sheasby, FRCO, head of school music, as conductor, Dursley Modern School had the nucleus of a band. From such a small beginning, the band grew in size, competence and reputation. In the beginning, it played to local audiences, but over the years, during which it became the band of Rednock School, it travelled far, wide and abroad; it did well in competitions, sold many records and tapes, broadcast on the radio and was televised.

To list all its events and successes would fill more pages than are available in this book. Suffice it to say, it gave tremendous pleasure to thousands of listeners in its time and gave to those in or associated with it much fun and feelings of great achievement. All this would not have happened, of course, but for the dedication and enthusiasm of John Morris – and his wife, Mary – both now living in happy retirement in Dursley.

REDNOCK SCHOOL

Problems with the 'eleven plus' system were eventually recognised by Parliament, and in 1965, it was suggested that councils might look at the idea of comprehensive education. It was an idea taken up in Gloucestershire, and by 1968, plans were in place to merge the two secondary schools in Dursley. After much discussion, it was decided to develop the Grammar School site to create Rednock Comprehensive School.

Roy Harper, BA, was appointed in 1970 to be the first headteacher of the new comprehensive school. He came to Dursley with the experience of having created one of the first comprehensive schools in the country: Farmor's at Fairford. His appointment a year before Rednock opened enabled him to work on merging the Modern and Grammar Schools. Working parties of teachers from the two schools met to thrash out how the academic and pastoral policies of the new school would operate. Positions of members of staff had to be organised, and this was not easy, as both schools had their own staffing structures in place.

On the pastoral side, it was decided to split the new school, from its first year through to the Sixth Form, into six houses. They were named after people who had influenced education locally – Katherine Lady *Berkeley*, Henry *Vizard*, Sir Robert *Ashton Lister*, *John Peet*, Ernest *Barrett*, and Percy *Woodland*. This system worked well, engendering loyalty in pupils and house staff and good relationships with parents, particularly those with more than one child in the school.

During the year leading up to September 1971, buildings were being erected on the Rednock site, which at times must have made it hard for Grammar School teachers and pupils alike. When September came, the new school was far from finished and temporary measures were put in place to accommodate everyone. What perhaps is surprising, is how quickly the comprehensive school settled down at all levels during its first few weeks. If there was any resentment by ex-Grammar School pupils at having their patch invaded by new-comers, it did not last long, and it says much for pupils from the Modern School, used to a highly disciplined environment in well-defined buildings, that they coped well with a more relaxed atmosphere and a sprawl of buildings – at least most did!

The site was not well designed, having the staff-room and school offices at one end of buildings strung out in two long lines. Most of the buildings were not linked by corridors or covered ways. One of the writer's abiding memories is the smell of wet clothes drying in classrooms after pupils had dashed from one building to the next on a rainy day.

The buildings for the new school were planned to arise in three phases. Phase one covered demolition of Rednock House, which had become too dangerous to use, refurbishment of many existing Grammar School classrooms and the construction of new ones, such as science laboratories and the main office block. This was largely complete by the time the school opened in September 1971. Phase two was more new buildings, including the three-

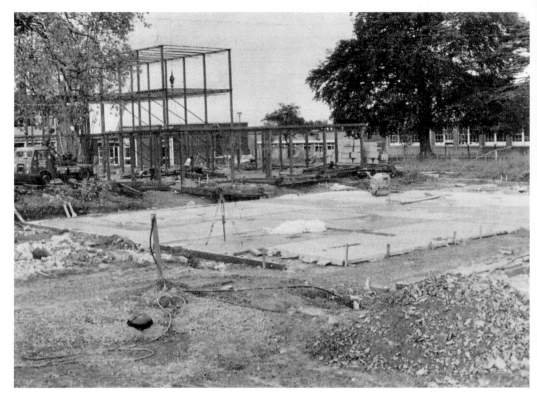

1972, preparing for new buildings. Behind a concrete slab for a house base is the girder framework for the three-storey block. (Photo: Richard Wintle)

storey block, and this was complete by 1973. Phase three was to see yet more building, including a Sixth-Form centre. It was never started, and so, for many decades, a multitude of temporary structures were in place for teaching. Not being designed for long-term use, they deteriorated and were replaced by yet more temporary buildings.

John Peet, headmaster of the Modern School for 22 years, saw out his teaching service with a year at Rednock as bursar, retiring in 1972. John Broomfield, acting head of the Grammar School, took on the role of deputy head in the new school, until his retirement in 1975.

Roy Harper retired in December 1987, leaving a school of which he could be proud. It had come to excel in academic work, on the sports field, in the fields of music, drama and the arts, and it gave the less academic pupils, as much as it could, a sense of pride in themselves. His place was taken by John Pritchard, and now David Alexander is at the helm.

The story of education in Dursley and its surrounding villages is a strong and vigorous one. Many headteachers had long reigns in their schools, thereby promoting stability. Most, private and state, were dedicated to their pupils. So far as secondary education goes, it is perhaps interesting to note that, since the state took an interest in Dursley in 1921, there have been only six headteachers covering 112 years. This, on average, is nearly 20 years apiece and can be replicated with many classroom teachers. The result has been settled, but not complacent, places of learning. Roy Harper and his staff in the early days of Rednock created a school of excellence. Today, that excellence is still present. The following pages give a glimpse, and only that, of some of the activities and memories of students and staff in the years between 1971 and 1999.

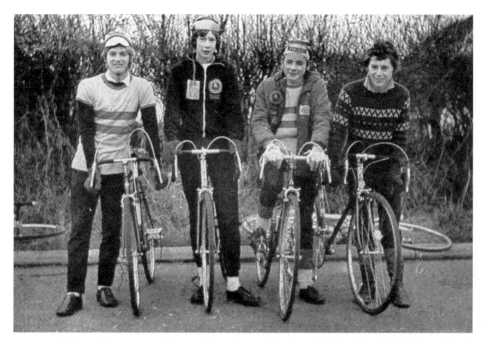

1972. Paul Short, John Sirrett, Philip Pimlot and Ivor Claridge. Like the school band, the Rednock School Cycling Club began in the Modern School. Members took part in racing events and on two occasions attended training weekends at centres of sports excellence. Touring was also popular and included summer holiday tours in this country and Europe. John is wearing a badge of the English Schools Cycling Association to which the school was affiliated. Over the years, the club has migrated to be the present town organisation, bearing the name Dursley Road Club. The picture is from the only issue (1972) of Rednock School's magazine *Quest*.

Pictures and Memories, 1971 – 1999
Barbara Grove remembers well her introduction to Rednock School:

Lucky Thirteen
On 22 April 1971, the Headmaster Elect, Roy Harper, and his deputy, John Broomfield, held a series of interviews for the post of assistant geography teacher and second-in-geography. The candidates assembled in the old TA Centre where they were given a description of the new school and shown a plan of the proposed three-phase building project and a scale model of the completed project...

On being offered the job, I, Barbara Hammond, accepted and then realised that I had not seen the Head of Geography, Ellis Williams, any of the staff, and even any of the facilities. Roy Harper commented that being his thirteenth 'new' teacher appointment, he hoped that I was not superstitious and then wished me good luck.

After the interview, I was taken to Rednock House, which was a rambling, decaying building with rotten floorboards with many holes in them. 'Be thankful that you will not be teaching in this building – it will be pulled down during the summer holidays,' said my guide Les Rhodes, who was going to be my Head of House. He introduced me, at last, to Ellis Williams.

There followed a quick tour of the site and the answer to another question – in which room will I teach? 'These will be temporary teaching rooms for geography and history,' said Ellis as he pointed to a collection of second-hand temporary classrooms stretching across the car park. 'We will also be having that building,' – he pointed to a pre-war, army-style

grey blob – 'once the Physics Department has been moved into the new science block.' He then added, 'It won't be for very long, as we are having a completely new set of rooms once phase three has been completed in a year or two!' What faith we all had in those days!

The Ghost of the Old Bell

In July 1971, Roy Harper summoned all of the staff of the new school to a meeting... Some (new) teachers chose to stay in the Old Bell without knowing each other or anybody else. During breakfast, a young lady and her aunt were in animated conversation about transport and the events of the day. The waitress informed the two ladies that 'the gentleman over there is going to the meeting and may be able to help with transport'. She approached the teacher and asked him if he would take the young lady to the meeting and he duly obliged.

In the evening, the aunt confessed that she had had a disturbed feeling during the night and was informed that she had slept in the haunted room of the hotel. She added that she had had a premonition that her niece, the young lady teacher, had met her future husband. Nobody thought anymore about this until 3 August 1974 when Miss Barbara Hammond married Mr John Grove and they were informed by Barbara's aunt that the premonition had come true!

The rest is history, but Roy Harper always professed that he was the guiding hand behind the first inter-staff marriage and that it was all down to him!

Rachel Finch, née Loewenthal, has happy memories of Rednock:

I attended Rednock between 1974 and 1979, along with my brothers and sister. We were unusual at the time, three of us being the only triplets!

Enclosed are some pictures of a musical production of *The Boyfriend*. I believe it was in December 1977 or '78. Even after we had finished performing it, we hung around in the drama hall at breaks and lunchtimes because nobody wanted it to end – we enjoyed it so much. The staff had to disperse us each time and eventually we got the message! At the time, there was a competition to design a poster. Kerry Lee won. It wouldn't be seen as very PC now with a cigarette on the front. We all thought it was brilliant! [Sorry we haven't the space to reproduce it here – ed.]

I used to wear a very non-uniform jumper. How did I get away with that under the nose of Miss McPherson [deputy head]? She had a reputation for being very strict about school uniform.

I also remember Jonny Morris' band. They were great! They entertained us in assemblies at the end of term and even the kids who were pretending to be 'cool' still liked them really. By the way, I was in John Peet House and remember doing a great many assemblies for my form tutor, Mr Lewis. His history lessons were always good fun as he had such a great personality.

Long stripy scarves and over the knee socks were seen as good to wear then. We would try to wear them to school to see if we would be spotted by Miss Mac. The boys had 'spoon shoes', as I call them, and very flared trousers with high waistbands. The girls had to have the perfect flick in their hair and would spend as long as possible in the loos trying to perfect it with masses of hairspray. It's a wonder we didn't all choke to death. I think our generation were probably single-handedly responsible for the hole in the ozone layer! Of course, we weren't supposed to be bringing hairspray into school. It was smuggled in. In that respect, I don't suppose things have changed much. I expect the girls are still trying to be as fashionable as possible – whatever the fashion is!

1972. 'Vizard 3' tutor group outside the wooden structure used by the Grammar School as an assembly hall and gymnasium. For Rednock School, it had been converted into an art studio, doubling up as a house base. Top, from the back: Jane Protheroe, Catherine Breen, Morwenna Payne, Kay Curson and Carole Eggington. Rowena Pierce, Anne Glover and Lynne Rennie. Amanda Francis, Sandra Sparrow and Kim Bennett. Avril Johnson, Phillipa Cantle, Moyra Gundvig-Nielsen and Francis Harrison. Bottom from the back: Bogdan Pawlyszyn, David Wilcox, Michael Lyon, Ian Evans and Jonathon Veale. Stephen Jennings and Raymond Williams. Anthony Malpass, Stephen Millard and Mark Bembenek. Phillip Arkwell, David Freeston, Timothy Witts, Simon Jerome, Paul Jameson and Nigel Smart.

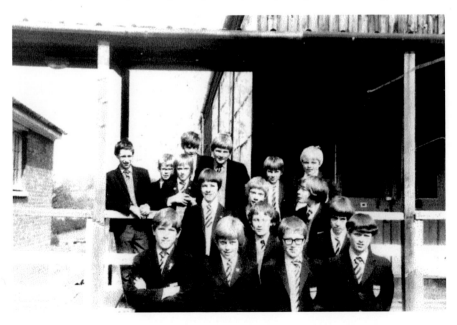

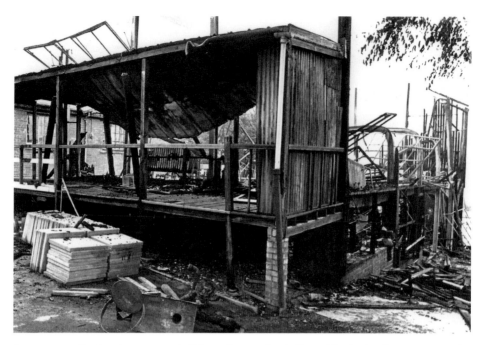

August 1973. During the summer holidays, the wooden hall used by Rednock as an art studio caught fire. The cause was never discovered. The hall was replaced by two temporary classrooms. (Photo: Ian Wilkins)

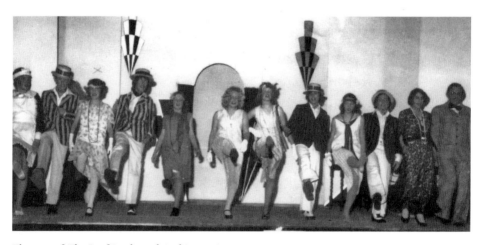

The cast of *The Boyfriend*, produced in 1976.
Jill Batchelor, Andrew Green, Rachel Loewenthal, Andrew Harn?, Anne Francis, Nicky Strong, Jane McNally, Andrew Bullock, Liz Aldridge, Neil Williams, Janita Brown and John Grove. Missing is Graham Tudgay.

In the spring of 1976, Anne Francis entered a national competition and visited Alexandra Place in North London to audition for a TV part. She was successful and played young Winifred Foley in an adaption of part of her book, *A Child in the Forest*, which was broadcast nationally.

The Boyfriend was a great success and other large scale productions followed, some written within the school. In the 1980s, for example, came *Amahl and the Night Visitors*, *Old School Tie*, *King of the Weavers*, *Hobson's Choice*, *Charlie and the Chocolate Factory*, *Good Queen Victoria and all That*, *Mystery at Greenfingers* and *The Truth is Out There*.

From Christine Reeves:

Another Way

When Rednock first opened, those who were not inspired by education gravitated to the Special Needs Department. Roy Harper soon realised we needed more space and allotted us three Terrapin [temporary] classrooms with a large area of grass behind them.

A considerable number of our pupils were from local farming families; they were not slow learners in the traditional sense, just disinterested in what was on offer. Our approach had to be quite different from that dictated by modern education if we were to engage these pupils in classroom activities with anything like enthusiasm.

English, Maths and some other subjects centred round the animals we produced and kept in our garden. The introduction of an incubator meant everyone could adopt an egg. Interest levels soon increased. It's amazing what you can do once everyone has a reason to look and learn.

Once chicks and ducks had hatched, they were kept at the back of our big Terrapin under an infrared heater. Temperature was recorded regularly, size and weight noted until it was time to move the birds outside. Here we were very lucky to have some second-hand poultry houses donated, which some of the boys renovated. Health and Safety did not come into it! Eggs were sold to help with the cost of buying food, and pupils were eager to come and spend time in holidays and weekends feeding and looking after our stock.

We had one panic. Although I did not go to school every day, our office staff were superb, and if a problem arose, the children would dash there and ask to speak to me on the phone. A fox appeared! He shot under the Terrapin and would not come out. The children did not like the look of him. I probably broke the speed limit on the road to Dursley, having told the children not to go near the animal. By the time I arrived, the fox had bolted and there were giant barricades against all doors and windows of the poultry houses.

The Wildfowl Trust, as it was then, gave us some duck eggs to hatch. We had a good hatch and the ducklings imprinted on the pupils who cared for them. One particular lad, once a non-reader, had produced some excellent work in a booklet for English. The booklet, all about hatching ducklings, had to be shown to Mr Harper. Little did I know, until my phone rang, that the lad had taken his pet ducks with him to the headmaster. They waggled all the way along in front of the house blocks, down the steps and in through the drama hall doorway, along the corridor and so to the headmaster's office. RJH evidently just smiled and complemented the lad on his efforts at English. The party then departed on the long walk back to R3. The phone call I had before they arrived will stay in my mind forever! I do not know if Sir was laughing or crying!

Later that summer term, the lunchtime break was suddenly disturbed by the majority of the SN pupils dashing round Rednock in a wilder fashion than usual. The ducks, now fully grown, had taken off and were flying round the English block. They came in to land in the swimming pool to everyone's delight. Not long after, they took off and went into the wild blue yonder. It was a sad day, but many lessons had been learned.

Sadly, our old Terrapins began to leak more then ever, and we had to find a new home. We had to behave more like the rest of the school! We transferred to an old kitchen, which was just right for us! Our poultry had to go, but a new interest in tropical fish took over, also free-flying budgies lived outside our classroom. We also had a lovely cockatiel who could imitate wonderfully a ringing school bell... but then, that's another story!

Rednock memories from Mandy Clutterbuck, née Taylor:

I started Rednock School in 1976 after a long hot summer. I remember as a very small girl passing the 'big school' on my way to my grandparent's house; it looked quite a daunting place.

In September, I duly went to Rednock. I quickly made friends and became part of several sports teams for Ashton Lister House. Some of the staff always insisted on calling me Amanda (there were several of us) but I was the only one christened Mandy so this rankled – the fact that I am writing about it now means that it still does!

My son is grateful that he does not attend Rednock School. He came home moaning one day about having to do cross country that day. As we live in a relatively built-up area in Cheshire, I was intrigued to know the actual course. 'Ten times around the sports field' was the response.

The conversation quickly turned into a Monty Python sketch (you know the type, who is most hard done by?) 'That's nothing; you should be grateful that you don't go to my old school. In my day they had a **real** cross-country course. Next time we go down to see Nanny and Grampy, you, me and Archie (the Labrador) will walk the course.' In time, we did so, without stopping for a rest in the now-derelict summerhouse with its breathtaking views across the Severn Valley and into Wales. We circuited Stinchcombe Hill after an initial steep climb and then we practically tumbled our way down again. My son conceded defeat; 'I'm glad I don't go to your old school, Mum!'

That course was one of the many character-building aspects of life at Rednock. I think they call it creating the *rounded individual* now.

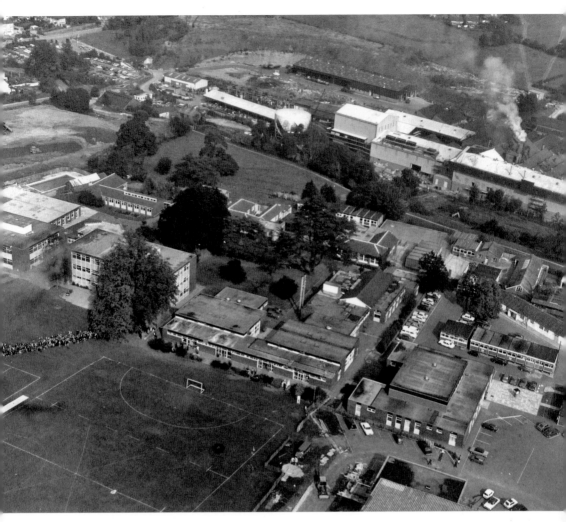

A view from the air of Rednock School in 1978. The many portable buildings which made up much of the school's structure can be seen easily. On the left-hand side, earth-moving machinery can be seen. Waste material from Lister's tip is being spread to provide, unsuccessfully, level playing fields in what had been a small valley dropping down from the Kingshill Road. All-weather play surfaces have now been laid down in the area.

The photograph was taken from a helicopter that was giving a demonstration to pupils – its shadow can be seen by the concrete strip.

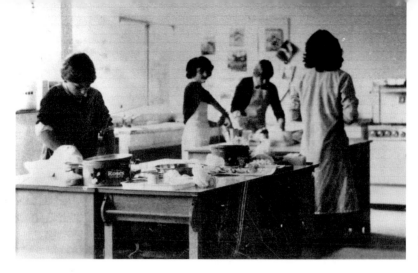

1981. Fourth-year boys enjoying cookery lessons.

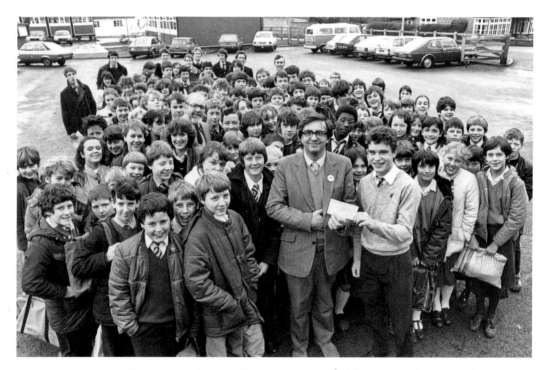

In 1982, sixteen-year-old Darrel Keep became ill with leukaemia and became confined to his home. His friends were concerned and raised £15 for games and the hire of a television set for his bedroom. This act caught the imagination of the school, and over several months, many fund-raising events took place – cake and popcorn sales, car washing, a two-hour sponsored silence, a sponsored walk along the canal from Purton to Gloucester and back by four lads, a raffle of toys, a sponsored trampoline bounce by Sixth Formers and much else. The school's cleaners held a raffle and donations came in from the Parents Association, the local police, the Royal British Legion and Cam Charities. Some £1,200 was raised, worth in 2009 values about £2,500. Some was used to provide items of Darrel's choice; some used to plant a ginko tree in the school grounds in his memory. The rest went to the Cancer and Leukaemia in Childhood Trust, CLIC.

In this picture Dr Meek of the Trust is receiving a token cheque for £200 from Paul Healey, Vizard House Captain. (Photo: Dursley *Gazette*)

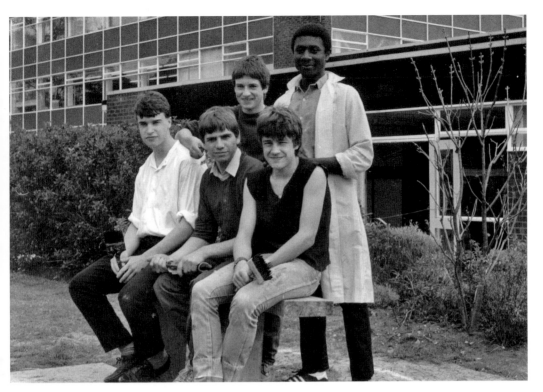

Five lads who had finished their fifth-year examinations and wanted something useful and physical to do – such as decorating a school cloakroom. Back row: Simon Bolton and Daron Subryan. Front row: Paul Healey, David Bennett and Peter Mills.

National Tree Week in November 1983 was supported by Stroud Tree Workshop. A member of this was Penny Land, head of grounds staff at Rednock. Through her, and with financial support from Dursley Rotary Club and the Dursley and Cam Society, it was decided to plant some 350 saplings of oak, ash, birch and alder on a bank in the far corner of the school's estate, next to Kingshill Lane.

The picture shows volunteers from Stroud Tree Workshop with members of Rednock School's Young Farmers' Club, Duke of Edinburgh's Award Scheme and parents taking a break in planting. Today, 2009, the trees have grown into a young woodland, adding shade and interest to the new gravelled footpath alongside Kingshill Lane.

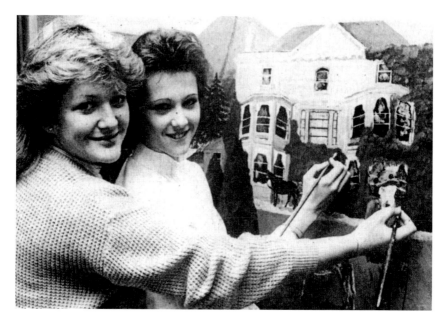

1984. In about 1982, the old Victorian cinema in Silver Street, Dursley, was converted into an arcade of shops. The then owner invited students at Rednock School to paint a 40-foot mural to hang above the shops, this to feature scenes from Dursley's Victorian past. Some twenty pupils became involved, working in their lunchtimes and after school hours. Here, Julianne Scragg and Darlene Daly finish the scene depicting Capt Graham with an Irish wolfhound outside his home at Rednock. (Photo: Dursley *Gazette*)

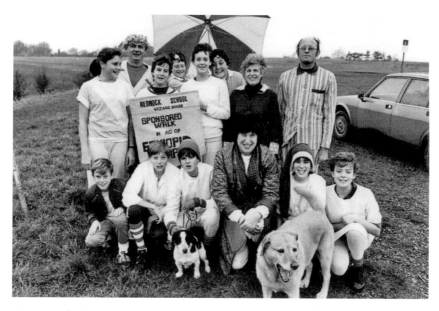

Young people from Mrs Ann Parrott's tutor group ready to set off on a 12-mile sponsored pyjama walk to raise money for the 1984 Ethiopian Appeal. It produced £130. Back: Rachael Chequer, Mr Wellings, Lucy Wellings, Shawn Cowle, Nicola Parves, Richard Lavington, and Mr and Mrs Bircham, aunt and uncle to Lucy. Front: Craig Lindsey, Richard Farmer, Paula Smith, Mrs Ann Parrott and Debbie Longman.

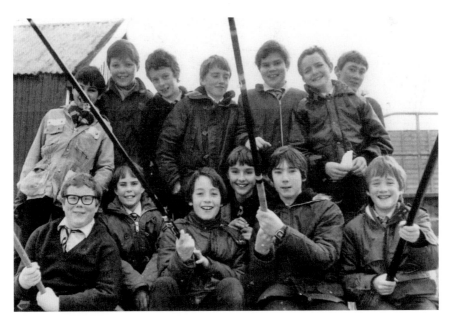

These happy lads from Rednock are taking part in an eight-hour sponsored fishing contest on Slimbridge Back Brook, which raised £200 for the 1984 Ethiopian Famine Relief Appeal. With them were Jill Holloway and Mike Lewis, members of the school staff. Back: Steve Hulbert, Mario Bertuca, Nik Blackmore, Mark Evered, Julian Jones, Paul Bennett, Bret Parker, whose idea this was, and Matthew Tipper. Front: Kevin Pankhurst, Julian Ashman, Jon Cruse, Martin Fowler, Mark Robinson, James Coleman and Grant Scott.

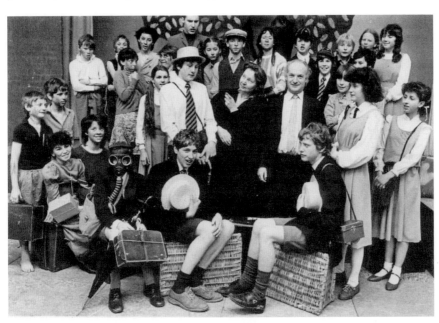

The cast of *Old School Tie*, produced in 1985 on the 40th anniversary of the ending of the Second World War. The 'self-penned extravaganza' was set in Dursley in that war and was a spy story involving children who had been evacuated to Gloucestershire. Writers were Christopher Gilmore, teacher of drama, and Lynn White, Head of Music.

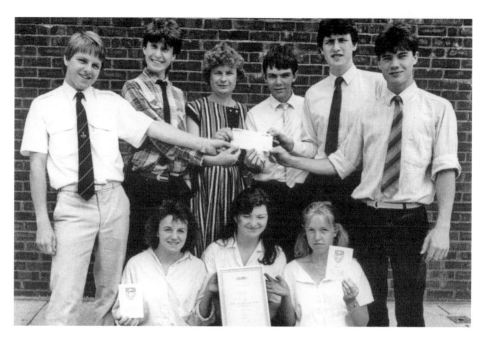

1987. These Sixth Formers had decided to enter a competition set by the English Tourist Board – and won, beating over one hundred other schools. The winning entry was a brochure giving details of places of local interest and tourist attractions in the Dursley area. It also included a map of central Dursley and useful telephone numbers. Local traders were approached to see if they would support the project through advertising, which many did. 3,000 copies were printed and given to the town library and other places for free distribution. They proved popular and another 3,000 were produced to meet demand. Winning the competition meant a visit to London and HMS *Belfast* to receive the prize of £1,250 and certificates. Back: Glenn Moulder, Adrian Sherratt, geography teacher Barbara Grove, Mark Birch and Toby Waterson. Front: Sarah Williams, Helen Williams and Jenny Boulter. Missing from the picture is Alistair Powell. (Photo: Dursley *Gazette*)

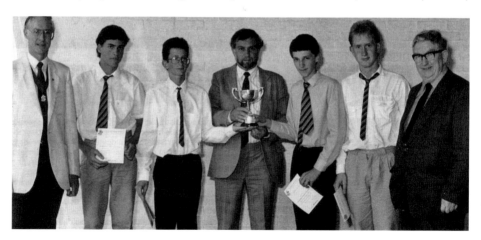

For several years, an annual computer competition for Gloucestershire schools was organised by the Gloucester and Cheltenham branch of the British Computer Society and sponsored by Eagle Star. In 1987, the two-and-a-half-hour problem-solving event was won by Rednock School, beating sixteen other entries. The winning team are shown above with competition officials and Maths teacher Frank Ratcliffe; William Beere, Timothy Board, Peter Durston and Richard White.

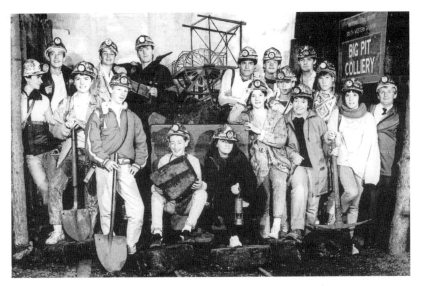

Pupils enjoying a visit to Big Pit, South Wales, during a Geography trip in 1988. With them are teachers Helen Baines and Ellis Williams. (Photo courtesy of Amgueddfa Cymru National Museum of Wales)

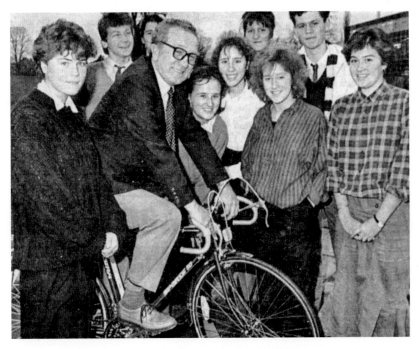

Headmaster Roy Harper retired from teaching in December 1987. His sixteen-year term of office had been an exacting one, not least in getting a new school up and operating and coping with the constant running sore of poor accommodation. He had, however, led the school to very high standards both academically and socially and his retirement was marked by many tributes and by a multitude of gifts from pupils. One gift was a ten-speed bicycle. Here, Roy is looking relaxed and delighting in the company of the Sixth Formers around him.

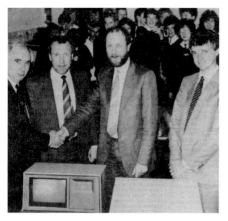

John Pritchard, BA Hons in languages, took up the duties of headmaster of Rednock at Easter 1988. His first teaching post had been at Taunton and he arrived in Dursley via Lord William's School, Thame, and King Edward VI College in Totnes, where he had been deputy head.

At Rednock, he was faced with a number of problems. The state of many buildings, of course, but also there was the need to implement the National Curriculum, due to begin in September 1989, and the need to reorganise the pastoral system to cope with the increasing complexity of developments in education. The school had for some years operated a truncated house system in which all first year pupils were kept together as a year group. This system was now to be adopted for the whole school from September 1989. House bases were to become year bases.

In the picture above, taken in 1988, John is seen receiving the gift of a computer from Brian Gornall, the Central Electricity Generating Board's technical support officer at Berkeley Nuclear Power Station. Watching are John Swann, deputy head, and Nigel Brookes-Smith from Berkeley Power Station. (Photo: Dursley *Gazette*)

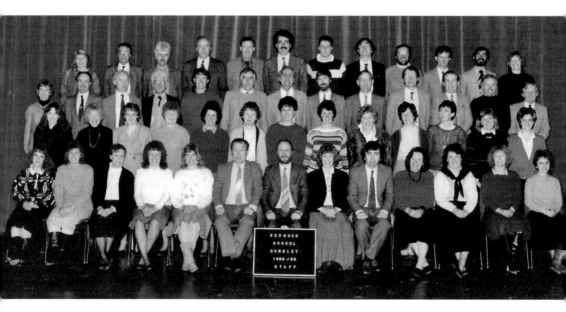

The staff of Rednock School in the spring of 1989; Back row: Margaret Driver, John Wathern (Bursar 1985-2001), Trevor Vick, Chris Veysey, Bob Vick, Maereg Lewis, Mike Reeve, Mike Lewis, Peter Kendal, Nigel Meredith, David Ashbee and Judy McLaughlin. Third row: June Reynolds, Neil Grecian, John Ewer, Bernard Ford, Graham Jones, Bruce Aldridge, David Evans, Andrew Pinch, John Grove, Edward Jones, John Williams, Winston Davies and Ellis Williams. Second row: Christine Counsell, Barbara Barnfield (Headteacher's Secretary 1969-2004), Lisa May, Barbara Grove, Jill Holloway, Audrey Butterfield, Joanne Hemper, Barbara Newman, Alice Hawken, Marion Miller, Judy Golding, Carol Lambert and Lynn White. Front row: June Fenwick, Alison McPhilips, Pam Pugh, Carol Cooper, Val Wright, John Swann (1st Dty HM), John Pritchard (HM), Penny Krucker (2nd Dty HM), Chris Steer (3rd Dty HM), Helen Baines, Alison Rumney, G. Kenny and Sharon Power. Missing are: Hélène Dalrymple, Huw Williams, Christine Reeves, Ann Parrott, David Stuckey, Linda Stuckey, John Daniel, Tim Harrison, Harry Myatt, Sheila Pritchard, Barbara McHale, Jane McKae, Alan Thomas, Martin Fardell, Peter Davies, Roger Ransome and Brian Wetton.

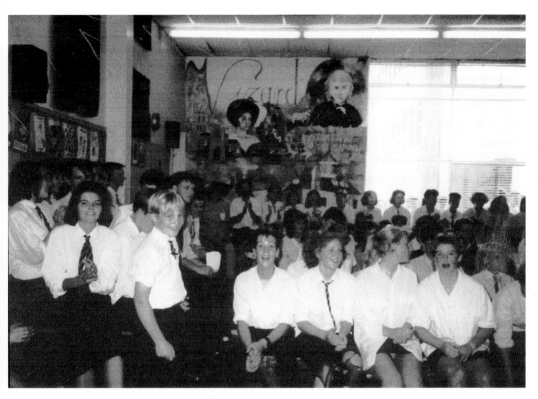

The last assemblies under the house system were held at the end of the summer term 1989 and various were the activities seen then. This picture shows pupils in Vizard House watching performances by their fellows to mark the occasion and to give retiring housemaster David Evans a good send-off. The two girls in the front row have obviously taken part in the event!

The mural in the background was painted by Art teacher Julian Davies and depicts some of the activities of the Vizard family. Top right is philanthropist Henry Vizard after whom the house was named.

These students were winners of the Dursley Rotary Club's 'Young Inventor of the Year' competition in 1991, and they are receiving prizes and certificates from Russ Holloway, second from right. Winner was Laurie Moir, centre, who received a cheque for £25. He had designed a walking stick for blind people which detected the presence of puddles. Edward Sawkins gained £15 for his fishing rod invention and Chris Rosser, £10 for a novel burglar alarm. With them is Alan Thomas, teacher of craft, design and technology (CDT). (Photo: Dursley *Gazette*)

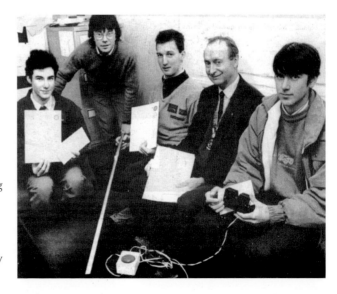

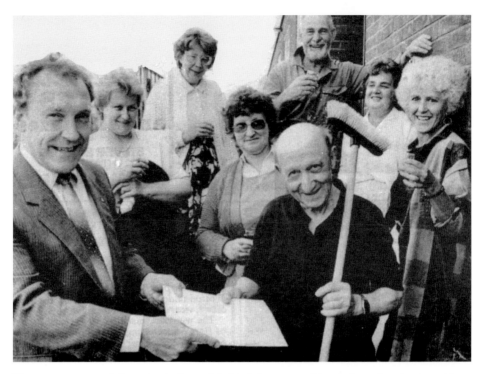

There are many people in a school who work behind the scenes without whom the school would not function – technicians, office staff, cleaners, grounds staff, caretaker, bursar, with perhaps medical and library personnel and the staff-room tea lady. Rarely are their praises sung – but they are vital.

In September 1989, a small ceremony took place in which the retirement of Cyril Lewis, head cleaner, was marked. He had joined the cleaning staff in 1975. Here he is seen with colleagues, receiving a cheque and a good wishes card from deputy headmaster John Swann.

From Chris Steer (Deputy Head 1988-1998):

It was a pleasure and a privilege to work at Rednock for ten years. My memories present a myriad of images of warm-hearted, wonderful colleagues and eager, enthusiastic and delightful students. I learnt so much from so many and remember the History 'A' Level groups as the happiest of classroom experiences. I can still recall the daily joy and laughter.

The heart of Rednock was much deeper than the buckets used to catch the rain in the History room, or the strength of the wind as it would howl around the year bases; it was an unstated calm commitment to the comprehensive ideal, based on the absolute belief that everyone could succeed and that traditional values and virtues should not be forgotten amidst the latest whim of Government.

And when the demands of the job or the events of the day ever seemed burdensome or dreary, there was always the glorious view of Cam Peak and beyond, or the majestic cedar trees at the heart of the site – to fail to be uplifted on such a site was quite simply impossible.

From John Pritchard (Headteacher April 1988 – August 2004):

As I drove down Whiteway Hill on that sunny morning in October 1987, I caught a glimpse of Dursley, Cam and Rednock School in the valley below me. From that distance, and that height, it all looked perfect. At that time, I was deputy headteacher at a school in Devon, and was now on my way for two days of interviews for the post of Headteacher at Rednock.

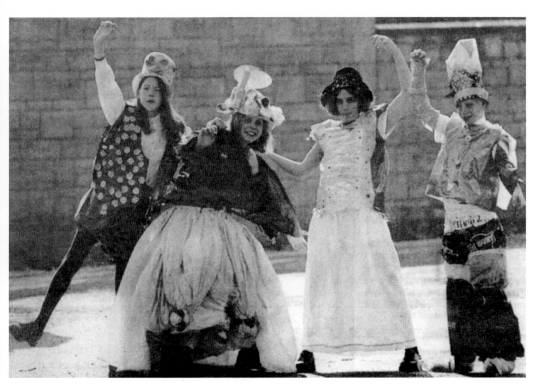

Fashion is rubbish – at least it was to Laura Dally, Louisa Beasor, Karen Jarman and Kevin Dowler in 1994. They were four of some two hundred pupils who put on a fashion show with an environmental theme that year. All the outfits modelled were made from second-hand clothing or from materials often classed as rubbish. The fashion evening was open to the public and the money raised went to charities including ChildLine.

During a tour of the school with the other candidates, the dreadful state of the buildings became painfully apparent. Indeed, one of the candidates withdrew his application at this point. What struck me, however, was that no matter how poor the structure and design of the buildings, there were excellent displays of students' work in the classrooms, very little litter, and no damage or graffiti. There was clearly great pride in the school, despite the challenging environment.

Over the next sixteen years, one of my major tasks was to campaign for improvements to the building stock, and we had some success in bidding for grants for new buildings: the Harper Building [Science and Modern Languages], the Drama Suite, the SciencePlus Centre, and the new music facilities. In addition, some of the existing buildings were refurbished, and some of the older temporary buildings were replaced by more modern temporary buildings!

I look back with great pleasure at the many successes the school enjoyed during my time there, but I also cannot forget some of the more difficult times we faced as a community, including the untimely deaths of colleagues, children, and parents. The way in which all the members of the 'Rednock family' supported each other during such difficult times was remarkable and very special.

I am delighted that students and staff now have the excellent buildings and facilities that they deserve: I offer my warmest congratulations to all those who worked so hard to achieve such a fine outcome. May that special 'Rednock spirit' live on in its new home!

Year 11 students of the new decade, the new century, the new Millennium – the Year 2000. They were also the first to do SATs (Standard Attainment Tests), CATs (Cognitive Ability Tests), and Post-16 AS examinations! With their Head of Year, 'Mrs D', Hélène Dalrymple.

The Ten Years Leading up to 2009

The following pages record some of Rednock School's activities and achievements since the turn of the century. There is no particular order in these except that, as the school is very much part of Dursley and the wider community, its links with the world outside its physical boundaries begin this section.

Student Links with the Community

As a school 'of the Community, for the Community', Rednock students have played an important part in fully achieving this aim through involvement in many activities such as: Scouts and Guides; the Dursley Swimming Pool Dolphin Club; great personal achievements with the 649 Dursley Squadron of the Air Training Corps over many years; membership of local and world environment groups; members of local youth, church and religious groups; involvement with nature conservation groups; members of local theatrical, dance and musical groups; members of out-of-school sporting clubs locally with impressive personal achievements; voluntary work helping community groups, care of the elderly and great involvement with primary schools; supporting local charities. Recently, Rednock students provided The Omega Tree sculpture for the Dursley Twinberrow Wood Sculpture and Play Trail. Students from each department within the school regularly take part and achieve impressive successes in local, district and national competitions of which we can only mention a few.

School Links with the Local Community, Businesses and Industry

Students in Year 10 and Year 12 complete a week of work experience at a placement of their choice which enables them to gain an insight into and practical experience of the world of work. Enterprise schemes at different levels are also encouraged. The police, social services, the health authority and various charitable and religious groups make a valuable contribution to the curriculum and wider life of the school. A Connexions personal advisor is available permanently to work with Years 9-13.

Local businesses and industry have supported the school through career conventions (biennial), joint projects and sponsorship. Following are just a few examples of past links:

- The school has been running a student mentoring scheme with outside volunteers seeing students on a regular basis
- 2000 – practical IT assistance was received from Research Machines Plc and a donation of £1,000 towards the CNC (Computerised Numerical Control) Lathe Fund
- 2001 – Rednock students took part in the BNFL (British Nuclear Fuels Limited) Schools Challenge Day; Adam Mukasa Yr9 received the Philip Lawrence Award for outstanding citizenship
- Yr12 students J. Skal, J. Prodger, P. Stevens and C. Stevens collected their Gold Crest Awards for creativity in Science and Technology. Working with Delphi Diesel Systems Ltd, Bath University and Laurie Moir (Technology Dept) to design and manufacture a unit to measure force applied to a test rig in the production line, involving research, manufacturing prototypes using high-tech equipment, attending lectures and consulting technicians. The results had to then be presented and a portfolio produced while preparing for AS levels. The unit produced is being used on the Delphi production line in place of the previous system
- 2002 – S. Hanley, A. Hopper, G. Rayner and E. Williams Yr13 won the Chemical Engineering Department, University of Bath competition sponsored by BNFL, Satro and the Institute of Chemical Engineers
- 2003 – three Yr10 students gained the Smiths Industrial Award for outstanding project work
- 2005 – Frank Applegate, owner of Applegate Coaches, donated funds for an official school sign, having driven buses to the school for over 50 years. Rednock to work on project 'The Business Language Champions Scheme' with local company Renishaw. Royal Navy Lynx helicopter visited Rednock Yr10 as part of their careers preparation
- 2006 – Renishaw Plc donated £50,000 for the Design Technology department to purchase 'state-of-the-art' equipment; Yr10-13 students took part in National Enterprise Week to discover, practise and refine crucial skills required by employers

Local UK Partner Primary Schools – Cam Everlands; Cam Hopton C of E; Cam Woodfields Junior; Coaley C of E; Dursley C of E; Uley C of E; St Joseph's RC Nympsfield.

School and Family Partnership
Praised by the Ofsted inspectors, the link between the school and parents begins before students join, through the prospectus, open days, introductory evening, and the Partnership Agreement, followed by curriculum information and the homework diary on joining. Parents' evenings, annual questionnaires and seminars for parents are further vital contacts. Rednock is very grateful to parents and supporters for their generous donations of school vouchers, which have provided invaluable resources, instruments and equipment for the students over the years.

Rednock Achievements and Successes – Just a Few!
- Chosen as the school in Gloucestershire, and one of a dozen in the country, to be a 'Pathfinder School' in recognition of Rednock School's high performance and innovative teaching, with £30 million to completely rebuild the school
- Continued excellent examination results at Key Stage 3 (Yr9), GCSE and Post-16
- Very good Ofsted Inspection Reports in 1999, 2004 and 2007
- Approximately 90% of students continue education/training after 16 and on average over 70% of Yr13 go on to university
- Increasing school population originating from over 30 partner schools and 25% of students come from outside the traditional catchment area
- Awards Evening held annually to reward students' progress and achievements in the previous year (first held in 1996)

- Post-16 students successful in Open University Science Short Course modules
- Rednock offers an Extended School Service, making the school resources and facilities available to the wider community, and runs a Literacy and Numeracy Summer School for Yr6 pupils
- From September 2006, the school works on a two-week timetable – week A and week B – starting at 8.35 a.m. and finishing at 3.00 p.m. with five 60 minute lessons each day
- Curriculum Enrichment Days are held during the final week of the summer term each year offering a wide range of interesting and fun learning activities for all years outside the constraints of the National Curriculum

Some school/student successes:

- 1997 – Charlie Dalrymple, Jenny Unsworth and Tracy Beames were offered places at Oxford/Cambridge universities and David Robb and Glynn Reed at Thomas Moore's Liverpool/Salford College to study Drama
- 2000 – Yr8 students P. Naumann, E. Price, D. Koole, N. Cook, M. Barton, S. Hubbard and O. Daniel were clear winners of Gloucestershire Countryside Challenge, beating 17 other schools, testing numeracy, cartography, marketing, design and model-making skills
- A. Barnes, I. Bye, A. Bull, D. Leivers, G. Pedrick gained places on an engineering course in Shropshire competing nationally against other Yr9 students and C. Forsyth, A. Lamb, J. Marsh and J. Harvey took first place in the Young Engineers for Britain project
- 2003 – T. Freeman, B. Gaytten, M. Tyler, H. Stayte and C. Pollard were nominated for Gloucestershire Young People's Award; H. Tipper, S. Wilde, E. Gent, S. James and E. Brown awarded Diana, Princess of Wales Memorial Award for Young People
- The Rednock website went online
- 2004 – Nico Mustafic Yr12 represented the Stroud District at a meeting in the Houses of Parliament for Democracy for Youth
- 2005 – Ceri Wills (15) elected to lead the Youth Council
- 2007 – Jane Pearce Yr13 joined Cam Parish Council – one of the youngest councillors in Gloucestershire and Gemma Sirett Yr13 featured as a columnist for the *Gazette* newspaper as a Rednock School Ambassador
- Fifteen Yr8 students took part in a national BBC project to produce a 10 min News broadcast – highlights broadcast on BBC Radio Gloucestershire
- Facts4Life course presented to the Sixth Form by GP Dr Hugh van't Hoff and a healthy choices game for primary school children devised with the help of Lottery funding
- All-school Anti-Bullying Week with poster design and plays. Sixth Form involved in peer mediation and blue balloons with anti-bullying messages released at the end of the week
- Yr11 students took part in National Enterprise Week 'Make your Mark' challenge to create an ethical business idea in one day – ideas included solar-powered car, fair-trade clothing and trendy recyclable bags
- 2008 – Gemma Gingel (15) elected Youth Parliament member for the Cotswold and Stroud constituency
- Peter Cawley (17) won a Google code-breaking competition and a fully paid trip to Google headquarters in California
- 2009 – Television crew for 'The Future is Wild' filmed Yr7 work for the skills-based curriculum and footage will be taken to Germany for editing then shown to teachers in Europe as an example of good practices

Student Charity Work

Through events such as non-uniform days, concerts, Christmas shoe-box appeals, cake sales and sponsored events, the school has been able to support charities including Children in Need, Red Nose Day, Winston's Wish, Comic Relief, the Spring Centre, Cancer Research, Remembrance Day Poppy Appeal, UNICEF, CLIC, LEPRA, RSPCA, Sargent Cancer Care for Children and charity projects overseas.

In 1997, for example, students raised over £1,000 for Children in Need and Pudsey Bear himself collected the cheque, flown in by a BBC helicopter on to the school field, and in 2001, Rednock School, Cam Everlands and Stone-in-Woodford Primary Schools donated clothes and blankets for the Indian earthquake transport. Many students have also undertaken individual fund-raising challenges including bike rides, abseiling and sponsored walks. Surplus furniture from the school move has gone to under-privileged students in Nicaragua.

Regular Lunchtime and After-School Clubs

The success of Rednock School over the years is due invariably to the enthusiasm and interest of the students but also undeniably to the dedication and commitment of the teaching staff, whose hard work has encouraged students of all ages to achieve their very best both academically and personally, within and outside the curriculum. Staff have, throughout the years, strived to provide interesting and varied opportunities and experiences for students to develop their interests and talents in as broad a spectrum as possible.

The spring/summer term of 2009, for example, included the following extracurricular activities, supervised and organised by staff:

- 10½ hours of lunchtime clubs per week: Lunch Club, Hockey – Yrs10/11, Girls Choir, Basketball, Writer Workshop, Cricket – all years, Reading Club, Africa Forum, Lord of the Flies production, ICT Access and Inter-Tutor Group Competitions. In addition, London Academy of Music and Dramatic Arts acting classes were available
- 32 hours of after-school clubs: Library access, Art extension classes for GCSE and A level students, Netball – Yr7, Catch-up Technology Club, Astronomy Club, ICT Access, Hockey – Yrs8/9, Training Orchestra, Rugby – Yr8, Football – Yrs7/10, Yr7 Science Club, Food Club – Yr7, Homework/Coursework Club, Netball – Yrs 8/9, Girls Football U15 and U16, Homework Club – Yrs7/8/9, Football – Yr9, Table Tennis, Food Club, Netball – Yrs10/11, Football – Yr11, Hockey – Yr7, Geography Club/Mind the Gap (Geography) alternate weeks, Cross Country – all years, Badminton – Yrs10+, 1st XV, Rugby – Yr10, Warhammer (futuristic, fantasy, tabletop, strategy battle games) Club

In addition, the Duke of Edinburgh Scheme activities, orchestra/swingband practices and approximately 10 hours of Extended School activities run by outside providers, including dance classes, Tae Kwon-Do and yoga, also take place at Rednock on a regular basis.

Specialist Science College Status

- 2007 – Rednock was re-designated as a Specialist Science College, having exceeded a number of its targets to provide a wide range of additional Science and Mathematics opportunities
- 2003 – From September, Rednock became a Specialist Science College providing extra funding in excess of £700,000 over four years, for more educational opportunities in Science, Maths and ICT for Rednock students as well as other local schools and the wider community, while pursuing a broad and balanced curriculum
- 2002 – Science Status College bid required £50,000 to be raised from commerce/industry in order for the Government to consider the application. To help raise this amount, an appeal was made for parent/student help – Rose Chard (Yr8) offered to provide and learn

a scientific fact for every £1 donated. Thanks to the generosity of sponsors, Rose Chard and the Rednock School Association who donated the shortfall, the total amount was reached

Student involvement in projects, some examples:

- **2000** – 20 Technology students help Bristol University with earthquake research, constructing models of buildings tested in a simulator
- **2002** – F. Speak, J. Caesar, S. Sharp and J. Pedrick (all Yr8) attend Salter's Chemistry Day at Bristol University involving problem-solving experiment in Chemistry
- **2006** – Grant received from the Royal Society to help promote science among girls including a project to study the chemistry of perfumes – Yr10 students working with industry and scientists to produce their own individual fragrances
- **2007** – Discovery @ Rednock Day held by the Science Department for primary schools, Rednock students and families, with experiments and activities to celebrate four years of Science School status with Dr Alice Roberts of Bristol University, star of TV's *Don't Die Young*, *Coast* and *Time Team*
- Year 12/13 Spectroscopy Tour at Bristol University
AS- and A-level chemistry students were invited to visit the school of chemistry at the University of Bristol with an introductory talk on the spectroscopy facilities available at the university and their uses. Postgraduate students then conducted a tour of the department, where students had talks on mass spectrometry, nuclear magnetic resonance spectroscopy, infrared spectroscopy and electron microscopy, provided by academic and technical staff. This involved students seeing for themselves analytical machines that are only normally seen in textbooks by A-level students, as collectively they are worth millions of pounds, and having a hands-on experience of infrared spectroscopy

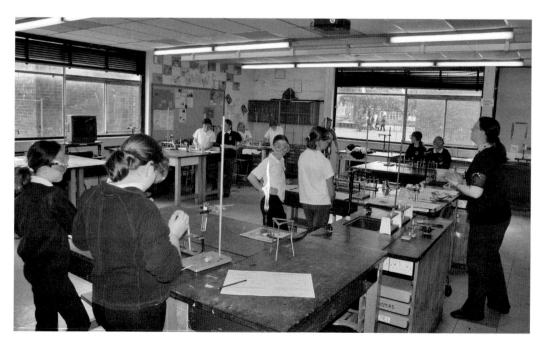

Year 7 Science, 2007.

British Council International School Award

2004 and 2007 – Rednock received the prestigious British Council International School Award after presenting a portfolio showcasing the school's international work covering a wide range of curriculum areas across the whole school, involving maximum numbers of students. The three-year award has to be reapplied for. International cultural and sporting links have included France, Germany, Italy, Spain, Japan, Sweden, Netherlands, Austria, Belgium, Malta, Hungary, Eire, USA, India, Barbados, Australia, Slovakia and Poland, with a visit to China due in 2010.

Reasons for international links/visits include: their contribution to multi-cultural education; contribution to students' spiritual, moral, social and cultural education; contribution to the development of particular skills, e.g., musical, sporting, linguistic; contribution to Citizenship.

Types of link/visit include: traditional mail service, e-mail, exchange of audio or videotape and DVD, video conferencing; residential or day trips; student exchange programmes and teacher exchange programmes. Through 'Project Trust' Rednock students have travelled overseas to help in developing countries. Examples of activities undertaken:

- **German exchange** – Dursley twinned with Bovenden, Niedersachsen, for 18 years
- **French Trip and exchange** – trip 2006 and Normandy Trip Yr7 2007
- **Spanish Trip** – Andalucia May 2007 Yr9 (trips to Spain for over 20 years)
- **Football Tour** – 2007, Valencia, Spain Yr12/13
- **Visit to Sikh temple (Gurdwara), Bristol** – July 2007, 220 Yr7 students. Visits to cathedrals, churches, synagogues and Hindu temples are also arranged.
- **Holocaust survivors** (London Jewish Cultural Centre) meet Yr9 History students at Rednock as part of their World War II project
- **Study of Japan** – involving 240 Yr8 students. Kazuhisa Teranishi (Kazu) visited from Japan as part of the International Internship Programme
- **E-mail link, visits and joint project with Polish school**
- **Pen-friend in Romania** – June 2006 and on-going link with Eastern Europe – Yrs7/9
- **Learning about Italy and the EU** – Yr8 Geography
- **Connecting classrooms** – 2006-9 – involving all Yr9. Partnership of three UK, three Ethiopian and three South African schools linked to promote understanding of each others' cultures and traditions through communication and project work
- **Talking about Faraway Places Event and Competition** – eight Yr10 Gifted and Talented students Jan/Feb 2007
- **Gaming Simulation – Sub Saharan Africa** – June 2007 – eight Yr10 Gifted and Talented students took part in the Science Festival at Cheltenham Ladies College
- **World Jungle** – Presentations to all Yr7-13 students by Ghanaian teachers involving environment, food and health, music, dance, culture and religion
- **Futuroscope, Poitiers, France – Specialist Science visit** – May 2007, Rednock students from Yrs7-9 visit jointly with students from cluster specialist science colleges
- **Refugee week** – June 2007, whole school, covering awareness of world refugee situations
- **Mackay North SHS, Queensland, Australia** – e-mail, post and visit contacts – links with Science department and exchange of data for scientific research
- **India Visit and India Friendship Club; History visits to Berlin and the World War I Battlefields; annual Watersports and Ski Trips; Orchestra Tour** (biennial)

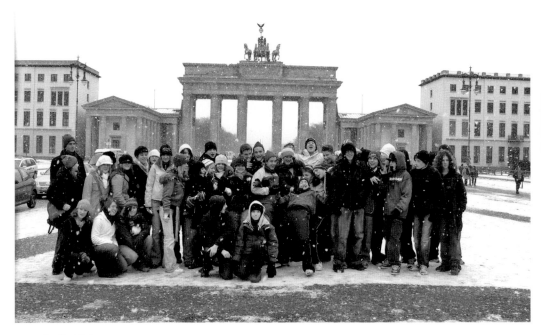

Berlin Visit, 2005.

Year 7 Normandy Trip, 2007.

The India Friendship Club

The club started in 1997 when Head of History Jenny Parsons visited India to set up a tie with St Andrew's School in Hyderabad and, involving Geography, RE and the History Department, arranged a range of cultural and fund-raising activities with three trips to India, December 2000, 2003 and 2006. The students stayed with host families, many still keep in touch by e-mail. One of the most popular and well-supported fund-raising events were the Dil Raj Restaurant evenings in Dursley, often attended by as many as 75 people. The owner, Raqib, a generous supporter of the club, sponsored sweatshirts for the last visit to India for club members to wear while travelling and visiting tourist attractions including the Taj Mahal.

The club raised funds for two projects in India, the Mother Teresa Orphanage in Secunderabad and the Bob Cotton School in Nalgonda district, named after Rednock's member of site staff and great supporter of the club Bob Cotton who tragically lost his life in the Paddington Train Crash in October 1999. The Dursley Rotary and Inner Wheel Clubs also provided funds for repairs and alterations at the Bob Cotton Junior School.

A presentation of the work of the India Friendship Club was made by Rosie Spencer, Rheanne Howell and Jenny Parsons to the Dursley Rotary Inner Wheel and Nicola Simpson wrote about it to the Stroud District Council. For their work for the club, Michael Pullin, Rosie Spencer and Lizzie Piper received the Diana, Princess of Wales Memorial Award for Young People presented by David Blunkett, Secretary of State for Education.

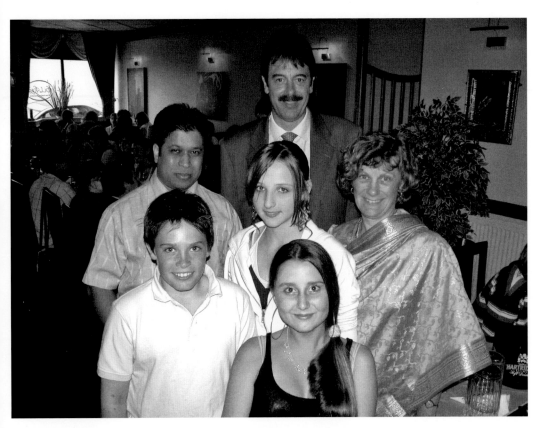

India Friendship Club fund-raising evening at the Dil Raj, Dursley.

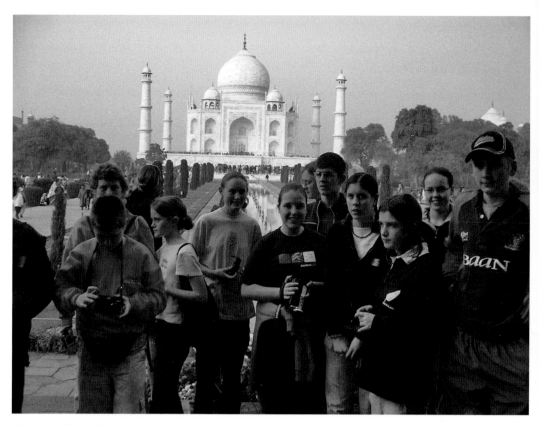

The Taj Mahal, India, 2003.

Links with Poland

Rednock Science College hosted a group of Polish students and their teachers from Przasnysz Public Grammar School, 100 km north of Warsaw, for a return visit in 2008. Contact between the two schools was established in 2006 when students from the Grammar School were staying at the Slimbridge Youth Hostel while in England on an independent tour and spent some time at Rednock, following which, the international link was formalised by Mr Walton (Maths) and Mrs Rushton (Science) for a joint environmental project with exchange visits, involving students setting up joint blogs and contacts.

The two schools worked on a 'recycling' project, detailed on the Rednock School website. Rednock visited Przasnysz in 2008 and worked collaboratively with the Polish students on a Science and Maths challenge as well as spending time developing their sporting skills. The Polish students were excellent at basketball and the Rednock students were able to give them an introduction to touch rugby which was well received.

During their stay, the Polish visitors met with local Polish residents (a large number having settled in the area after the Second World War) at the Community Centre. Mr Nawrot, president of the Polish community, gave a moving welcome speech and Mrs Radoszewska, a Polish resident also present, wrote an article about the visit which featured in the (UK) *Polish Daily News.* The contact between the two schools has been very successful with many friendships made and is part of an on-going exchange programme.

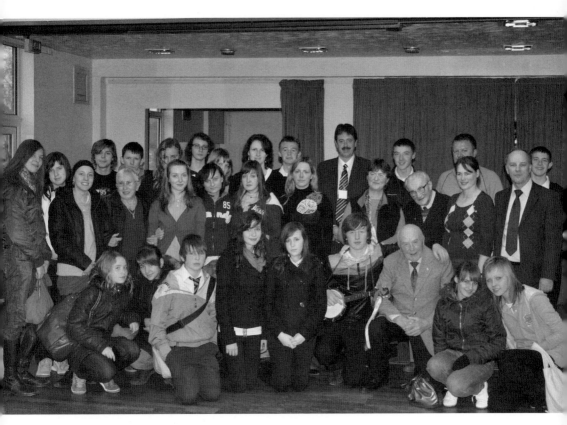

Polish and Rednock students with teachers and local Polish residents, 2008.

National Sport England Sportsmark Award

- **2000** Rednock awarded the Sportsmark Award for developing sport to a high level and participation with the local community through extracurricular sport
- **2003-2006** - re-awarded to the school for excellence in sport. Rednock School boasts a wide range of sporting activities and successes, which we soon realised would take up a book on their own so we have only been able to mention a few. Countless achievements have been made on a personal and school level in sports including rugby, football (boys and girls), cricket (boys and girls), rounders, netball, basketball, tennis, swimming, athletics, cross country, hockey, badminton, golf, gymnastics, orienteering, squash, trampolining, volleyball, aerobics, weight training, polo, horse riding, rowing, fitness and dance

- **1991** – Visiting football team from Auckland Grammar School, New Zealand, touring England played Rednock
- **1994/5** – Super Schools Project with visiting sporting celebrity, gymnast Lee Harris
- **1998** – New artificial cricket wicket, funded by the English Cricket Board and the Foundation for Sports and Arts opened by former England cricketer Tom Graveney
- **2000** – Yr7/8 Netball tour to Malta and no soccer finals were played due to foot and mouth disease
- **2005** – Bryan Draper, Managing Director of Lister Petter Ltd presented Rednock with new first team rugby shirts sponsored by the company

Multi-sport Barbados Tour, 2008.

- **2006** – Rednock received Gloucestershire Charter Standard Secondary School of the Year award for services to school football, presented by footballing legend Geoff Hurst
- **2007** – Rednock school presented Connecting Classroom project visitors from Africa with specially designed project bags for students and the teachers were also given a full Rednock football kit
- **2008** – Barbados multi-sport tour

Year 7 Boys Rugby 2002 – Twickenham

On 4 May 2002, the Rednock U12 Rugby team travelled to Twickenham to play in the final of the *Telegraph* Emerging Schools Festival, at half time during the Army and Navy Game, with a crowd of 40,000. The team 'produced a near-faultless display to walk away with the honours'. The team had put in an 'outstanding performance to gain their place in the final, competing in seven qualifying matches without conceding a single point'. (*Daily Telegraph*, 9 May 2002).

Watersports – Annual event

- **2001** – Watersports Trip to France – Yr8 canoeing, sailing, kayaking, windsurfing, white water rafting and bodyboarding

Year 7 Boys Rugby at Twickenham, 2002.
Twickenham, the home of rugby, May 2002 – what an awesome day that was! Ben Dix, Matthew Billett, Joshua Hemper, Steven Lane, Matthew Hillier, Tom Broomfield, Anthony Wait, Hugh McIntyre, Oliver Halford, Stefan Hawley, Daniel Brooks, Oliver Winterbottom (Capt), Jordan Lewis, Ashley Caldwell, James Wetherley, Jak Evans.

- **2007** – Trip to France and Spain with 38 Yr8 students to the French Alps and Costa Brava for rock climbing, mountain biking, white-water rafting, kayaking, snorkelling and sailing. The trip is an excellent teambuilding, physical exercise and cultural experience

Ski Trip
The ski trip is an all-age annual event and has been running for 20 years. Organised by Andy Sharp, Karen Rushton and Simon Moore, countries visited include France, Austria, Canada (Banff, Quebec) and USA (Stowe). In addition to physical education, the trips develop language and team-building skills, cultural experience and citizenship. Main activities are skiing/snowboarding.

Artsmark Award
The school received the Arts Council England Artsmark Award three times: 2002-2005, 2005-2008, and 2008-2011, for commitment to art forms including drama, music, design, literature, dance and sculpture at school and at an extracurricular level, e.g., Cheltenham Literary and Dance Festivals; public speaking, poetry and writing competitions at local and national level; Art department trips to view artwork in England and overseas, e.g., Barcelona. Examples of activities:

- **1996** – A level Art exam painting by Max Patte was chosen by Cambridge University Examination Board for their 1997 calendar
- **1998** – five students highly commended in the *Daily Telegraph* School Newspaper Awards for their *Rednock Herald* publication – G. Evans, G. Pedrick, K. Liu, L. Richardson, P. Watts
- **1999** – Matthew Barton Yr7 interviewed by Radio Gloucestershire about his poetry in the *Young Writers* magazine and poems by Mark Jenkins and Zoe Wilcox printed in new book by Gloucestershire writers *More Words in Edgeways* with work by David Ashbee, U. A. Fanthorpe and Joanna Trollope.
- Yr8 History students perform Elizabethan play at Nympsfield, North Nibley, Slimbridge and Cam Woodfield
- **2001** – The English Shakespeare Company worked with Yr9
- **2002** – Rosie Chard and Ceri Cockram prize winners in the Stroud Young People's Poetry Competition; Vicky Martin Yr13 had an article published in *The Historian* magazine; L. Piper, N. Blackmore and A. Smith won the John Templeton Award for Citizenship on behalf of Rednock in an essay-writing competition on moral education and citizenship
- **2003** – S. Poulson and J. Hemper won 1st Prize in the Festival of Languages Poster and Reader competitions respectively
- **2008** – Callum Sharp, Leanne Clark and Ellie Waterer Yr8 represented the school at the 'Youth Speaks' competition in Monmouth run by the Rotary Club

Watersports Trip to France and Spain, 2007.

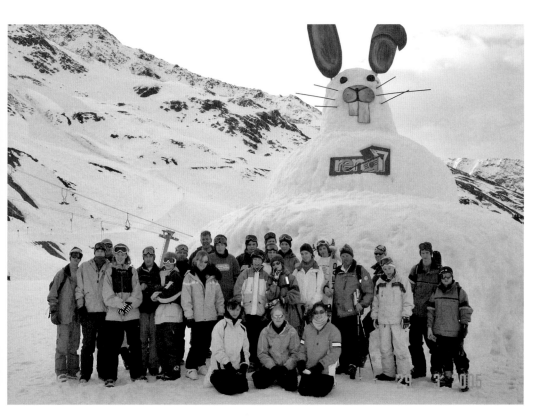

Skiing in Austria, 2005.

Skiing Trip, 2006.

School Achievement Award – Examination results in 2002 were so good that the Department for Education and Skills awarded Rednock £33,000 to be distributed in cash bonuses to the staff, teaching and non-teaching.

Healthy School Status – Rednock named as example of good practice in the LEA Healthy Schools Initiative 2007.
- **1997** – Food Tech students appeared in guidance notes of the Design and Technology Association national magazine as an example of good practice
- **2006** – National Food Safety Week – including chip-pan blaze demonstrated by Gloucestershire Fire and Rescue and a Caribbean cooking presentation
- **2008** – four students take part in Rotary Young Chef Competition finals

Investors in People Status 2007 – This award is in recognition of development of those working in the Rednock community.

**Membership of the National Association for Able Children in Education
Feb 2008 – Feb 2011**

2002 – Rednock is affiliated to the Technology Colleges Trust.

Yr 10 Enrichment Painting, 2009.

Music

Instruments available for students to learn include: violin, viola, cello, flute, oboe, saxophone, trumpet, trombone, electric/acoustic guitar and drums, with voice tuition also available. The Senior and Junior Orchestra, Choir, Swing Band, Recorder Ensemble and various smaller ensembles/duets perform at approximately fifteen concerts per year.

Swing Band Tours overseas: Paris (2002), Prague (2004), Italy (2006), Austria (2008).

Some examples of Music Department activities:
- Rednock School Band donated 26 old instruments to young musicians in the South African township of Soweto
- 27 musicians took part in the world's largest orchestra in Birmingham in 1996 – 2,845 musicians, under the baton of Sir Simon Rattle, won a place in the *Guinness Book of Records*
- The Welsh National Opera worked with 24 students at Rednock (the first school in Gloucestershire) in a two-day workshop
- Rednock Singers performed in concert in the Lister Hall for Kosovo refugees and took part in the annual Thornbury Eisteddfod; soloists of the Rednock School Orchestra performed at the Berkeley Music Festival
- Rednock Singers and Band entertained the Princess Royal and the Town Hall Trust in 2000
- Rednock musicians/singers regularly take part in local fetes, festivals and carnivals as well as Christmas carol concerts

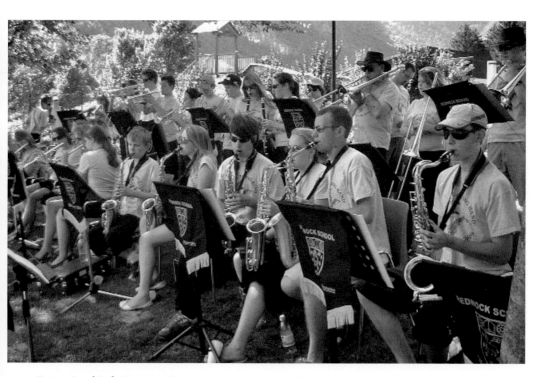

Swing Band Italy Tour, 2006.

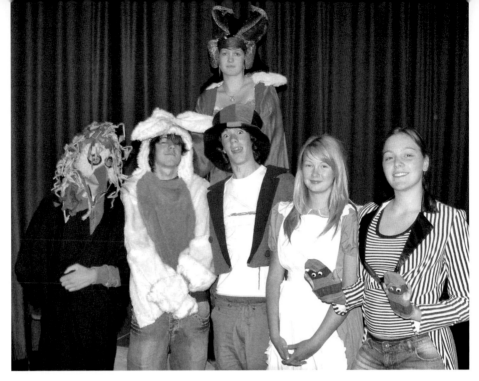

Drama – *Alice in Wonderland*, 2006.

Rednock School Productions – Directed by Mandy Johnson

Little Shop of Horrors (1991)
Oliver (1992)
Sweeney Todd (1993)
Grease (1994)
The Wizard of Oz (1995)
Bugsy Malone (1996)
Charlie and the Chocolate Factory (1997)
The Truth is Out There (1998)
A Decade of Drama (1999)
The Boyfriend (1999)
A Midsummer Night's Dream (2000)
Romeo and Juliet (2004)
Much Ado About Nothing (performed outside due to a power cut!)
Curiouser and Curiouser (2006)

In past years, Rednock drama students have been chosen to take part in BBC television programmes such as *Timebusters Series III*, and as extras in *Blackhearts in Battersea*. Some students were also given the opportunity to perform at the Playhouse Theatre in Cheltenham in *The Demon Drummer*, written by Jamilla Gavin (Young *Telegraph* Writer of the Year) as a special commission.

In 2008, over £1,000 was raised for charities in memory of former students Louisa de Brito and David Robb, donated to Cancer Research UK and Epilepsy Awareness.

Grease workshops have become very popular with students of all ages and especially with primary school pupils on their introductory day visits.

The Duke of Edinburgh Scheme

The scheme is open to all students from the summer term of Year 9 onwards and has been a strongly supported extracurricular activity at Rednock for many years. In the early 1990s, organised by Helen Baines, the scheme had more Rednock students participating than any other school in the county and Rednock was a flagship for the scheme in the South West of England. In April 1992, of 1,100 students attending that year, 88 students were working for the bronze award, 20 for the silver and 13 for gold – eight students were also invited to Buckingham Palace to receive their gold awards. Activities fall into four categories, Physical Recreation, Expeditions, Skill and Service, and include water sports at South Cerney Outdoor Education Centre; skiing at Gloucester Dry Ski Slope; expedition training at South Cerney, in the Forest of Dean, the Black Mountains and locally; conservation at the Slimbridge Wildfowl and Wetlands Trust; work at animal shelters; first-aid and life-saving courses; work with primary schools and the elderly.

The Rednock School Association

The RSA was established in 1971 and plays a vital role in the success of the school. In addition to arranging events at which parents, families, students and staff can socialise, they raise essential funds throughout the year. Events organised have included Quiz Night, Christmas Draw, Summer Draw, Cheese and Wine Evening, Race Night (with sponsorship from local businesses), Bingo Night, Autumn Ball, Line Dance, Treasure Hunt and Barbecue, Wine and Tapas Tasting Evening, Christmas Craft Fair and Barn Dance. The association also runs the 201 monthly draw club. An average of £5,000 is raised annually.

In the year 2000, for example, the following purchases were made: video projector £3,300, five televisions £1,011, five display boards £700. £1,000 was given towards a milling machine for Technology and another £1,000 towards curtains for the Drama Suite.

The RSA contribute to costs ranging from special PE kits and Sixth Form diaries to whiteboards and electronic equipment, and provided the final £5,000 required for the Science College bid.

Site Improvements Over the Years

- **1996** – work to improve Sixth Form corridor completed and carpet laid
- **1997** – front of school and field security fencing completed. New area created for the dustbins, allowing student seating area to be developed. Sixth Form patio and additional classrooms created. Two new classrooms built for Maths and C6 demolished. IT3 converted ready for new computer network
- **1998** – new seating areas created around the site and gardening club did a grand job planting and caring for areas around the school. Leyhill Prison volunteers completely redecorate the Drama Hall
- **1999** – The LEA became responsible again for allocating funds for building projects – estimated £5 million required to bring buildings up to standard. Request received to sell piece of land for the relocation of Dursley fire station. New Drama Suite opened and 'time capsule' buried at the entrance to mark the end of the millennium. Flat roofs of the Science Block and three-storey block were renewed and indoor Sixth Form toilets completed – no more sub-zero temperatures in the winter using outdoor toilets! Car parking extended by 30 spaces behind the Sports Hall. More improvements/decorating of classrooms, year centres and Director of Sixth office
- **2001** – eight networked ICT rooms and 130 networked computers with Internet access achieved. Learning Centre set up as part of the Learning Support provision. Bid by LEA made to the Department for Education for complete rebuild scheme for Rednock, ready for 2005. Two new student drinking fountains installed and automatic sensors fitted in the staff room/sports hall to conserve energy

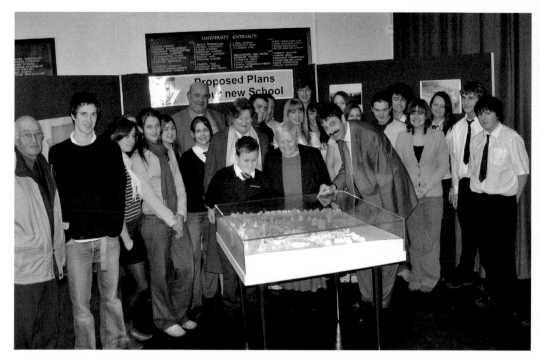

The Student Committee, School Ambassadors, Headteacher – David Alexander, School Governor – John Cox and community representatives discuss the 'Plan of the New Build' in 2007.

- 2002 – bid for new build unsuccessful. Geography block (in use for 50 years although only temporary), G3 and Z1 demolished and eight new pre-constructed classrooms for Geography and History put up. More flat roofs replaced
- 2003 – heating problems through the winter months left the admin block without heat for a week in February. Sewer collapse affected Yr11 boys' toilets. Frequent electricity supply problems. (Admin staff sprinted across the school site ringing the old school hand bell to shouts of 'bring out your dead!' and 'hear ye! hear ye!') – new build desperately needed!
- 2004 – opening of the new Science Plus building providing a lecture theatre/demonstration laboratory, by Sir David McMurtry, Chairman and Chief Executive of Renishaw Plc and major sponsor. Old Band Room converted into ICT room and equipped for Humanities.
- 2005 – opening of the new John Pritchard Centre for Music providing a recital room, two ensemble rooms and a recording studio. Announcement that Rednock is to receive £21.3 million for new build
- 2007 – Student committee engaged in working with architects on the new build beginning in November – 12 school ambassadors are chosen to keep the local community groups informed of the progress of the plans

The Library

In the past five or so years, there has been a revolution in the information world and computers have become the most popular method of information retrieval. At Rednock, students make good use of this facility for research and regularly use PowerPoint to produce well-informed presentations and homework. The Connexions Resource Library houses university/college and careers information including literature on student support and guidance. At the same time, books have been increasingly important, particularly to support the curriculum, with themed book boxes being supplied for the classrooms or information lessons organised in

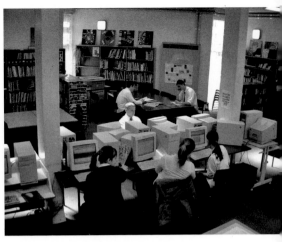

The Library – outside. The Library – inside.

the library. Popular book clubs for both staff and students have encouraged an enjoyment of reading fiction with special events organised, such as the 'summer reading challenge' when everyone was encouraged to send back, from their summer holiday, a postcard review of a book they had read while on their summer break. A quest to find Rednock's favourite fictional villain was also organised – resulting in Voldemort (Harry Potter series), of course!

Book sales and sponsored readathons have supported special charities over the years, as well as promoting a love of reading – a vast improvement since the early 1990s when, in December 1991, the local press reported that 900 books had to be withdrawn from the Rednock Library as the school could not afford the £2,000 fee being charged by the County Library Service.

The Library is very popular at lunch and breaktimes, when students seize the opportunity to catch up on homework, read quietly or play games from the selection available. Student Librarians contribute greatly to the success of the Library by helping to issue and return books, answer queries, sell stationery and run a computer booking system – a valuable work experience for them.

Mary Bennett – Librarian

The Learning Support Department

This is the biggest department in Rednock in terms of staff numbers, with typically 20 to 30 members of full- and part-time staff, most of whom are Teaching Assistants (TAs). They provide in-class support for students with a variety of difficulties, from dyslexia to physical disabilities. There is an Inclusion Unit, known up to 2009 as the Learning Centre, where individual students can work with adult support in a calm and quiet environment until they are ready to return to lessons. The department provides support for literacy and sometimes numeracy difficulties, handwriting issues, social, behavioural and emotional difficulties (S.E.B.D.) and the whole range of disabilities. Some students took part recently in the Gloucestershire regional sports day for disabled young people and performed well. Department staff accompany disabled students on trips to enable their inclusion in all school activities. The commitment of staff to the young people they support extends well beyond the classroom and includes home visits and representation of students' needs at multi-agency meetings.

Alison Denny – Head of Learning Support Department (S.E.N.C.O.)

Anti-bullying Week Awards 2007 – Keziah Cook, Mercedes Cornock, Grace Withey and Rory Rodrigues receive the Princess Diana Award for their contribution to the Anti-bullying Week. With them is Headteacher David Alexander.

The Sixth Form

Rednock Sixth Form has always had an excellent reputation and plays a very important part in the school's success. During the twenty years since I had the 'pleasure' of being the Director of Sixth, I saw many changes. Taking over from Julian Lailey in 1988, the largest ever Sixth Form of 155 students increased over the years to peak at 280.

Although the majority of students followed a traditional A-level route, vocational courses were introduced and became increasingly popular, with successful collaboration with Stroud College – Dursley annexe. The Sixth Form was truly comprehensive, meeting the needs of the local area and giving students a range of courses to suit their interests and ability. Curriculum 2000 saw students having to take external exams in Year 12 as well as Year 13.

Some staff found it difficult to accept the changing Sixth Form and dress code, looking back with nostalgia at 'the good old grammar school days' when students had to wear a uniform, with a Rednock Sixth Form tie and badge, expressing outrage when girls wore a green jumper or a red skirt – quite unacceptable colours. A 'no jeans' policy followed, with frequent discussions about what were and weren't jeans. Wanting to show their individuality, some Sixth Form students will push boundaries and their interpretation of smart casual does differ! The majority, however, do get it right. Fashions change and girls in Rednock Sixth Form in the 1970s only being permitted to wear 'trouser suits' from October to March reflects this.

The central focus of the less-than-satisfactory Sixth Form accommodation was B9, a 'temporary' building which served as a common room/assembly area. Totally inadequate, it gave you a free shower when it rained and was eventually condemned and replaced with the BQ and E-Rooms, but at least it was home. Students looking back affectionately should be grateful to the B9 kitchen for building up their immunity against a whole range of microbes.

Many students have gone on to be highly successful in their chosen careers and those who have gone to university achieved excellent results, but the Sixth Form is not just about academic success, it attempts to produce well-balanced individuals giving students the opportunity to participate in a wide range of extracurricular activities including sport, volunteering and work experience. The Sixth Form Committee is instrumental in making being in the Sixth Form fun, but I recall the 'custard vote' had to be stopped when one unfortunate girl had terrible trouble getting gunge out of her hair as it set solid thanks to wallpaper paste being used in the concoction. The yearly Christmas Review has been a highlight, although I still have nightmares as a result of some of the acts – the Pinchy and Trev sketches and staff pantomimes have become legendary.

Looking to the future, I am envious of the new school, the improved Sixth Form accommodation and facilities but Rednock Sixth Form is more about the people involved and I am sure that it will go from strength to strength.

Andrew Pinch

Sixth Form – Director of Post-16 with Tutors 2009, and behind to the left, the last remaining piece of wall (grey) from the original Rednock House: Gill Kenny, Ellie Martin, June Fenwick, Ann Hobdell, Hannah Wiltshire, Andy Wallis behind Jo James – Director of Post-16, Kate Alexander, Matt McCarthy, Ian Cole, Jenny Norris, John Davis – Deputy Headteacher, Trevor Vick (missing: Jason Andrews, Jenny Parsons, Angela Hughes, Nigel Pyman, Simon Moore).

Rednock changes its name – all in a good cause – Red Nose Day, 2009.

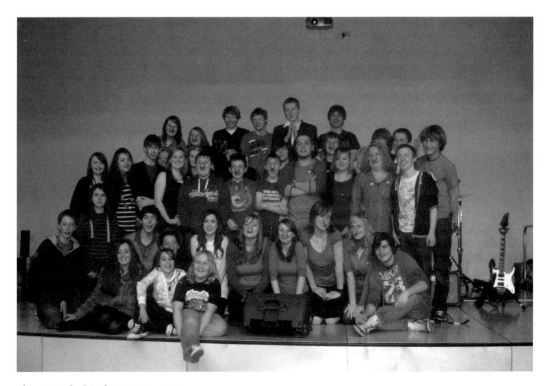

Show in aid of Red Nose Day, 2009.

Year 13 2009

13NIP – (Nigel Pyman/Simon Moore): Alice Vick, James Drake, Tom Stevens, Adam Wait, Suzanne Stanley, Danielle Carr, Ben Rulton, Chris Wilcox, Oliver Steel, Charlotte Griffiths, Guy Simmonds, Doug Walton, Charley Matthews.

13KAA – (Kate Alexander): Louise Cole, Richard Baker, Evelyn Williams, Gabi Dix, Lily Cowley, Hannah Penlington, Charlotte Morgan, Claire Read, Rob Standen, Josh Hill, Vicky Shier, Rosie Jones.

13AH – (Angela Hughes): Cassie Baggs, Hannah Linton, Claire Hitchcox, Olivia Graham, Owen Smith, Anna Wright, Jack Miller, Bradley Dessi, Callum Hubbard, Dan Pope, Luke Ward, Toni Vonk, Lorna Dewey, Oliver O'Connell.

13GK – (Gill Kenny): Sam Alvis, Robyn Bailey, Charlie Bird, Ben Deacon, Grace King, Maisie Meredith, Sophie Lea, Ella Opher, Hannah Parsons, Catherine Pollard, Olivia Scott, Ben Delafield, Morgan Wise, Jacob Gamm.

13JAA – (Jason Andrews): Jack Allen, David Hamilton, James Johnson, Jenny Hill, Emily John, Jessica Smith, Clare Rogers, William Sealey, Faye Tollerton, Ashley Peachey.

13JAP – (Jenny Parsons): Magnus Betts, Peter Cawley, Georgia Gibbs, Georgia Johnson, Richard Boroughs, Emma Roberts, Gemma Sirett, Rosie Coates, Chloe Lynn, Emma Gazard, Paul Atkinson, Ryan Hemper, Rachel Elliot, Laura Harris.

Sixth Form Committee 2008-2009
Year 13: Peter Cawley, Lily Cowley (Deputy Chair), Lorna Dewey, Gabi Dix, David Hamilton, Josh Hill, Callum Hubbard (Chairperson – Head Boy), Sophie Lea (Chairperson – Head Girl) Maisie Meredith (Deputy Chair), Hannah Parsons, Catherine Pollard, Tom Stevens.

Year 12: Libby Bartlett (Deputy Chair), Amy Cole (Chairperson) Matt Gabb, Georgia Harris, Amber Johansen, Sarah Jones, Lucy McNab-Jones, Joe Shuttlewood, Glyn Smith (Chairperson), Jess Tronier, Fergus Watson (Deputy Chair), Faye Wilson.

From David Martin (current Chair of Governors and a Rednock student when the school was first formed):

This book has described many aspects of life at Rednock, showing how the school has developed from its early days to the present momentous step of moving into a new building. Although the building itself is a marvellous facility, and will be a great asset for teaching and learning, any school is much more than just its buildings, its exam results, its current staff, or even its students. A good school provides a well-rounded education, sits at the heart of its local community (while also fostering international connections), and has a strong sense of its own identity and history. Rednock School provides all of these and was recognised in its most recent Ofsted inspection as a good school.

The Governing Body has 18 members including staff, parents and other members of the local community, and contains a wide range of skills. They meet as a body at least six times each year with a number of subcommittee meetings used to focus on particular aspects of the school's running and development. All members are volunteers who give their time because of their belief in the school and the importance of the rounded education that it provides. The school has foundation status and the Governing Body not only employs all the staff, but also owns the land and is responsible for the upkeep of buildings as well as setting the strategic direction of the school. Major building work,

such as the recent rebuild, is performed by Gloucestershire County Council in partnership with the school.

More recently, as part of the new build, Rednock has become one of very few schools in the country to be given money under the Government's Faraday project which aims to explore new ways of teaching science. As well as using sets of laptop computers with 'Augmented Reality' to aid understanding of details of science experiments, Rednock has the only school-based example in the country of a 'power wall'-driven immersive discovery room. This circular room, with a set of synchronised computers and projectors, will be able to show wrap-around views of areas of the world for detailed study, will be able to operate as a collaborative base for students solving simulated challenges such as natural disasters, and support a wide variety of computerised experiments and discoveries. Very few universities have facilities like this and Rednock will definitely be in the forefront of advanced science teaching for the Faraday project.

David Alexander, the current headteacher, has built upon the campaigning work that his predecessors Roy Harper and John Pritchard, governors, parents and local politicians have performed over the years, to finally get a building suitable for a modern school. Together with staff and governors, he will be leading the school into styles of education that obtain the greatest benefit from the flexibility that the new building provides, while also preserving all of the great features and traditions of Rednock.

I feel it a great privilege to be part of the school as it moves into its exciting new stage. As a new boy at the school, I would never have believed that I would one day be receiving the keys to such a landmark building!

Generations at Rednock

The local community is fairly stable with many families having links to the area and its schools that go back several generations. One is the family of Susan Morgan, née Manning, who joined Dursley Grammar School in 1962 and who revisited its site, now Rednock, in June this year, 2009.

Susan remembered the three houses of Marlowe (blue), Grenville (yellow) and Raleigh (red), the way boys and girls were separated in class and on the playing fields, and the insistence that beret or caps had to be worn at all times when going to and from school.

Her daughter, Barbara, was at Rednock in the 1980s. One memory was of how the roofs of the Geography and History rooms leaked in the rain, but despite all the problems, she enjoyed school life – something she put down to the teaching staff. She too revisited the school and found that the Home Economics room had the same workstations and smelt just as it did years ago.

Harriet Niblett, a granddaughter of Susan, attended Rednock between 2002 and 2007. Buckets to catch water from leaks were a memory as was the need to pick out half the stripes in one's school tie if one was to be 'cool'. Mrs Wiltshire had been her Psychology teacher and now she is looking after her children in a nursery school. In September 2009, Harriet's younger sister will be one of the first pupils to join Rednock and not know the old school. She says she is envious of the opportunities the new building will provide her sister!

FOND FAREWELL (OLD REDNOCK)

Sad and alone she sits and waits,
Thinking few will mourn her fate,
Broken windows, leaky roofs,
Stairwells scratched and grooved;
Humbled, crushed and cast aside,
None respectful of her pride.

Tall and proud She stands and waits,
Confident She'll captivate
Students, teachers, parents too,
Praising virtues as they view.
Showing off She little knows
Of fading memories over there.

Brave and dignified now she waits
As nobly she accepts her fate;
When all the dust is cleared and gone
Thoughts of her will linger on.
Demolition can't erase
Memories of former days,
Of protégés and tearaways.
So Brave Lady rest in peace,
No grand imposter can replace
A Legacy!

By Jacqui Cockram – Teaching Assistant

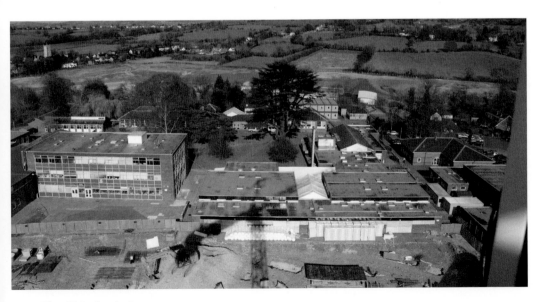

The old Rednock site.

CONCLUSION

Inheriting a school which had a reputation for poor buildings was quite a challenge. It meant that I had real encouragement to develop the school site. Early on, we wrote a clear brief for the future Rednock.

Sustainability was a key feature of the design and was something which came from the students – they wanted the school to be ecologically beneficial. Consequently, we have solar panels to generate power from the sun, a wind turbine, rainwater harvesting to recycle the water 'captured' on the roof, a biomass boiler plus much more.

The partition walls were important as they offer flexibility – classes can be joined if an 'expert' in a particular field starts the lesson, off then the walls can be closed if needs be; the 'pods' inside the school offer a 'break out space' for small groups of students to work quietly; the atria can be used for independent study or as social spaces according to the time of day. In short, maximum use of all the spaces demands flexibility, hence the main hall being used for assemblies, concerts, lessons, eating, exams, community projects and so on. The dining hall connects to the main hall by means of partition walls so that we can have one very large space to accommodate around 800 people. In the future, we want the community to use the school as well; after all, £30 million of public monies have been put into a fabulous resource. As for the school itself, we are aiming to become a 'great' school. I believe that we are already a good school; a few more 'tweaks' and we will become great. This year's exam results at GCSE were the best ever, so we have made a strong start!

David Alexander – Headteacher

AND FINALLY...

A big Rednock 'THANK YOU' to all those, **past and present**, who made our motto of 'Partnership, Quality and Success' a reality and for so often 'going that extra mile'.

THANK YOU to past headteachers; members of the Governing Body; members of the Senior Leadership Team; Heads and Assistant Heads of House/Year; Heads of Department; Teaching Staff; the IT Support Team; Primary Liaison Officers; GITEP Scheme Trainees; Examination Officers and Invigilators; Librarians; Cover Organisers and Supervisors; Learning Support and Learning Centre staff; Science, Technology and Art Technicians; Finance Department – who know what stretching the pound really means; the Admin team; the First-Aid Ladies; the Site and Maintenance team with the unenviable task of keeping the school in working order; the Catering Staff, Cleaning Staff and Lunchtime Assistants; and lastly, Mrs Edith Palmer, who, at the age of 82, still came to see to the teachers' morning break, having completed 16 years with Rednock, always smiling and cheerful.

Mrs Edith Palmer.

Thank you Parents, Post-16 Committee members, School Council members and Ambassadors, and most of all, thank you to all the Students, for a job excellently done, *as a new and exciting Rednock chapter begins*!

David Alexander – Headteacher

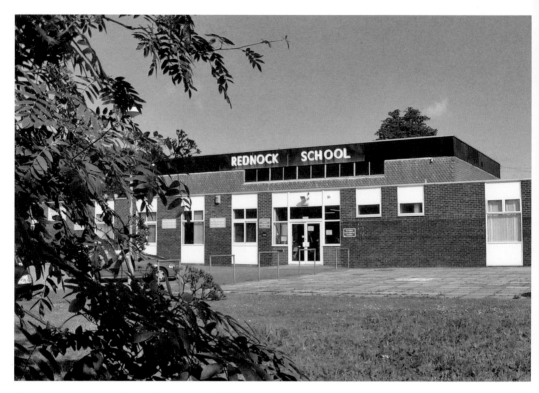

The main entrance to Rednock School until Friday 17 July 2009.

1 The badges of Dursley's secondary schools.
Above left: a. The badge of Dursley Secondary/Grammar School was adapted from the coat of arms of Sir Ashton Lister.
Above right: b. The quadrants of the badge of Dursley Modern School represented industry, faith, agriculture and learning.

c. The Rednock badge was an adaption of the crest of Dursley Rural District Council. The crosses on it represented the number of parishes within the RDC. These were reduced for the Rednock badge to show the parishes in the school's 1971 catchment area.

2 December 1980 and pupils in Year 11 are taking mock exams in the drama hall. Invigilators had to be careful with footwear lest, in walking the aisles, shoes squeaked on the polished floor.

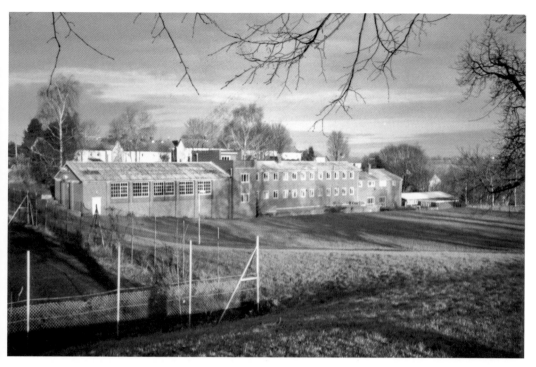

3 & 4 The former Territorial Army Hall in Kingshill Lane. This was adapted for use by Rednock School and housed a gymnasium, the Music department and the caretaker's flat. These tennis courts are now largely covered by Dursley's new fire station.

5 In 1987, former student Ann Marshall visited Rednock to talk about her experiences in China. She is seen here with Art teacher, Julian Davies, and pupils who have made a Chinese dragon.

6 Year 7 pupils Robert Hutt and Ian Hammil with copper sulphate crystals they have grown in Chemistry lessons (1989).

7 Bernadette Pye, Year 7 in 1989, enjoying a shocking time with static electricity in a Physics lesson.

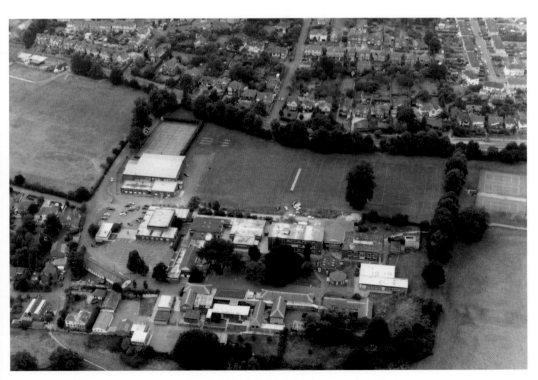

8 An aerial view of Rednock School taken in about 1995.

9 Visit to India, 2003.

Awards

10 Set of six silver spoons with Dursley Secondary School crest, awarded one year to Miss Beatrice Burchett (award reason unknown) Photo by great-granddaughter Hannah Linton (Yr13 2008-9).

AWARDS EVENING

7.30 p.m.	Welcome from John Pritchard (Headteacher)
	Opening remarks Alan Caig (Chair of Governors)

Presentation of Awards for Work in Year 7

The Shadow of your Smile (J. Handel)	Daniel Higgs Year 8
Allegro from Concertino (Kuchler)	Amanda Hopper Year 8

Presentation of Awards for Work in Year 7

Bonjour	Mark Butcher Year 8
The Elephant (Saint-Caens)	Maxine Woodward Year 8

Presentation of Awards for Work in Year 8

'Once' (Katie Pritchard)	Katie Pritchard Year 9
Menuette (Jean-Jacques Naudet)	Bridget Higgs Year 9
Theme & Variations	Joanna Skal Year 9

Claire Spruce (Year 11) will be playing music as guests arrive and leave.

Presentation of Awards for Work in Year 8

Folk Song	Rachel Hobson Year 10
'There I've said it again' by R. Evans and D. Mann	Colin Forsyth Year 10

Presentation of Awards for Work in Year 9

Solo piece for piano Chopin Prelude	Alice Harney Year 10
Allegro from Six Petits Duets (Pleyel)	Melanie Hopper and Sarah Hayward Year 10

Presentation of Awards for Work in Year 9

Closing Remarks Joyce Holborow (Deputy Headteacher)

Poem by Michael Thompson Year 9

Coffee will be served in Woodland House at the end of the Awards

11 Awards Evening programme 21 October 1997 – awards presented for work done in Years 7, 8 and 9 of the previous school year.

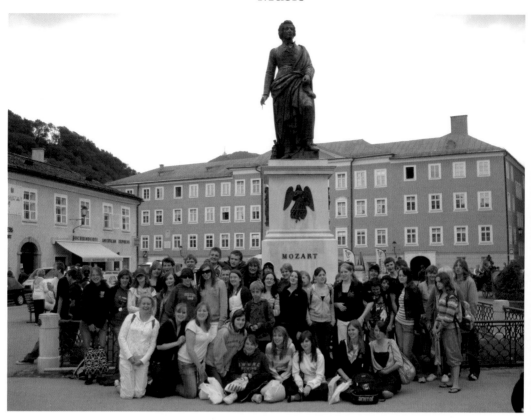

12 Music Tour, Austria, 2008, with Music teachers Jason Andrews and Lorraine Merchant.

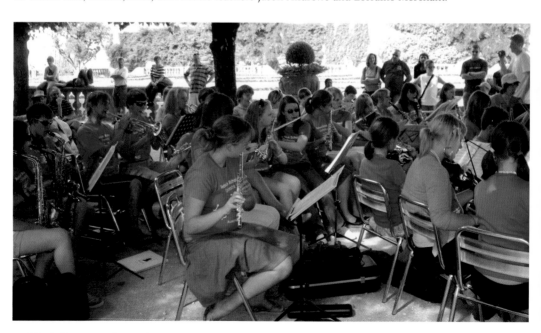

13 Music Tour, Austria, 2008.

Drama Production

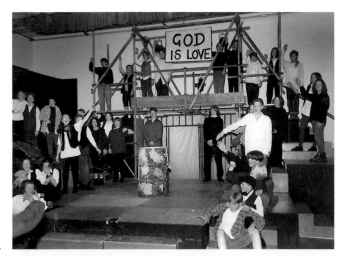

14 & 15 *Oliver* – Drama, 1992.

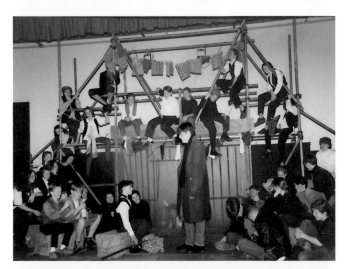

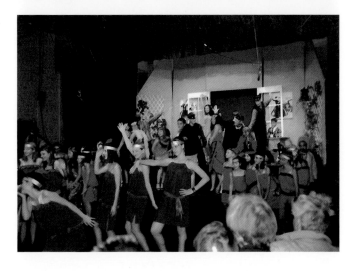

16 *The Boyfriend,* 1999.

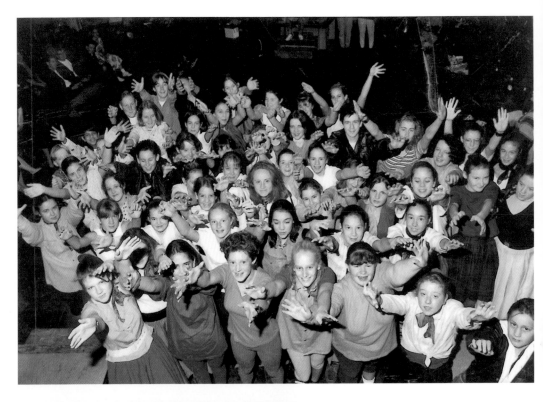

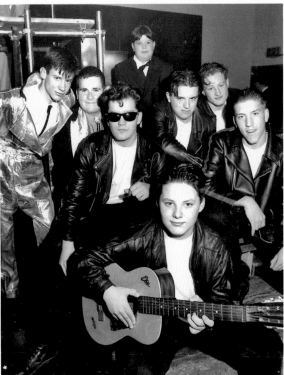

17 & 18 *Grease* – Drama, 1994.

Students at Work

19 Art lesson.

20 Science lesson.

21 Technology lesson.

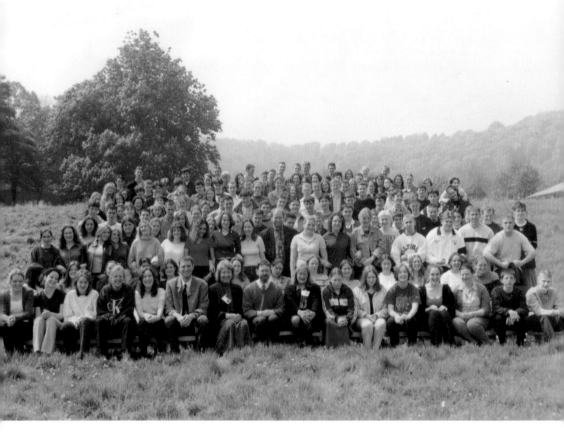

22 Sixth Form, June 1998.

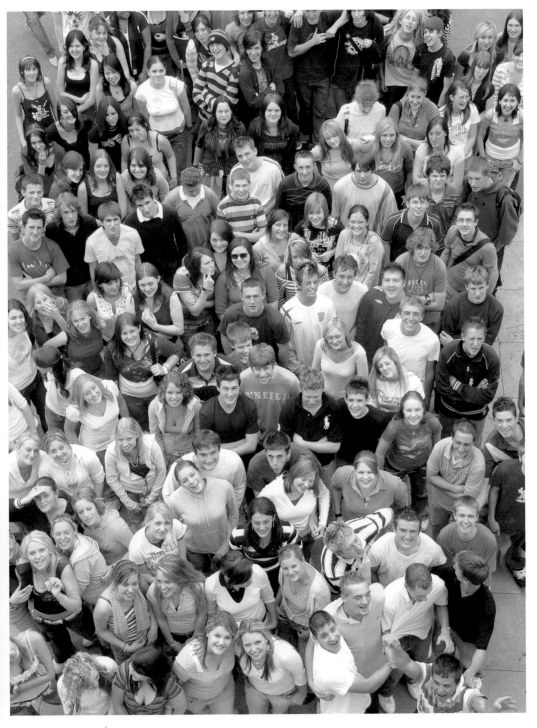

23 Sixth Form students, 2005.

24 Andrew Pinch holds final Sixth Form assembly, May 2008, before retiring as Director of Post-16.

25 Year 13 Leaving Day May 2008 with Andrew Pinch look-alike!

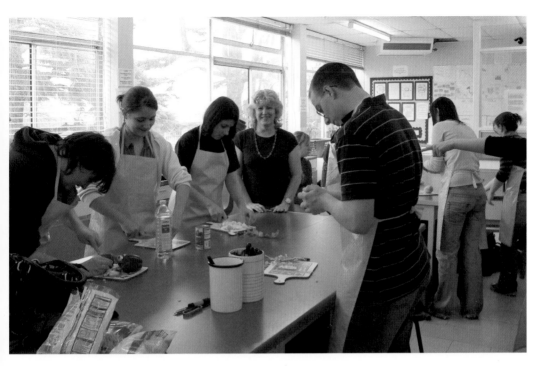

26 Sixth Form 'Can Cook Will Cook'?

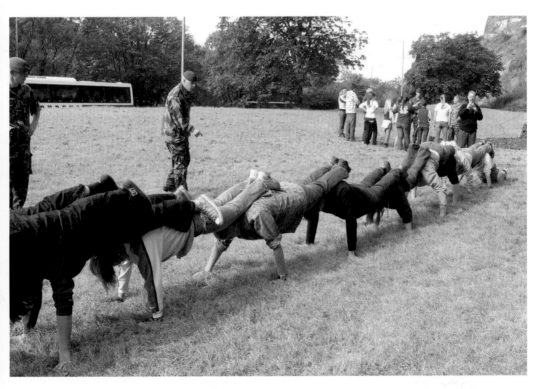

27 Sixth Form abseiling training!

Above: 28 Sixth Form peer mentoring.

Left: 29 Year 13 in the Sixth Form
Atrium of the new building October
2009.

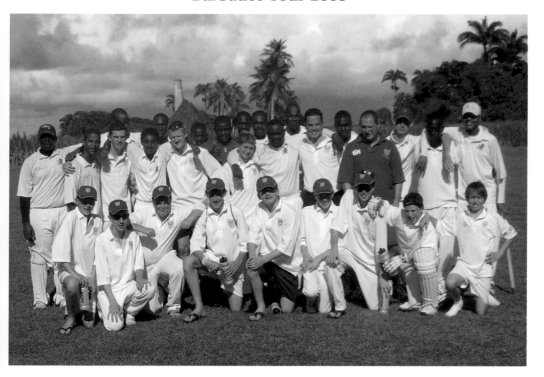

30 Cricket in Barbados, 2008.

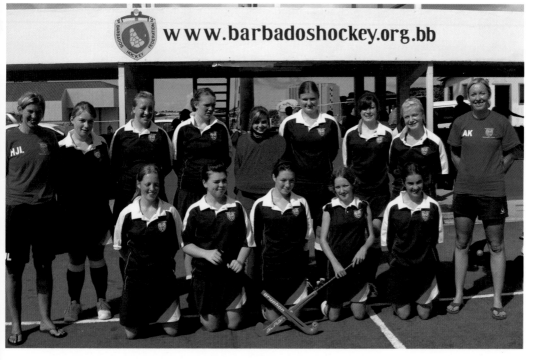

31 Rednock girls hockey team in Barbados, 2008.

32 Netball in Barbados, 2008.

33 Rednock football in Barbados, 2008.

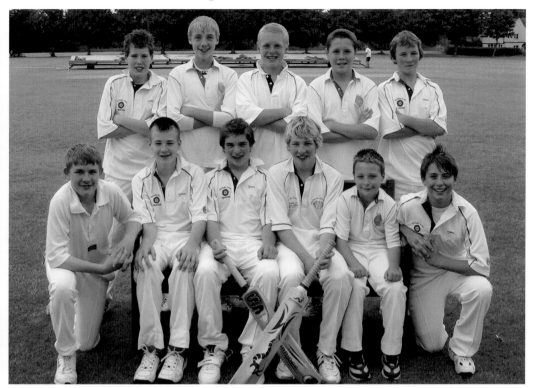

34 Year 7 and 8 cricket team, 2006.

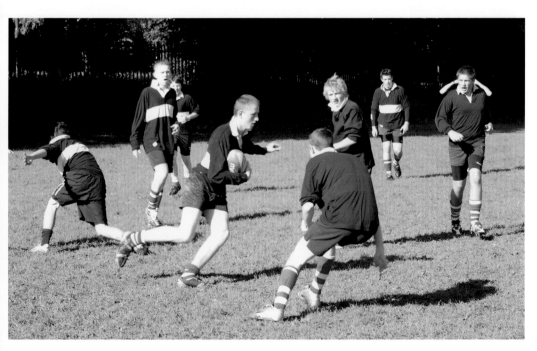

35 Rugby practice.

36 Football final, May 2006.

37 Football final, May 2006.

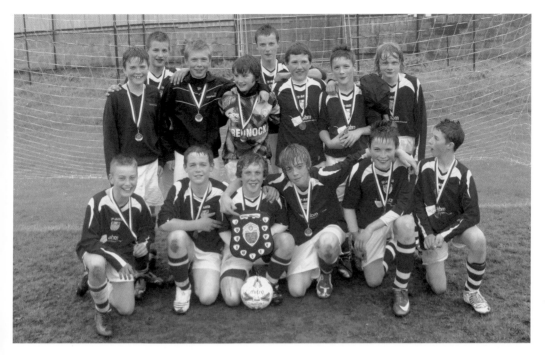

38 Year 8 Football finals, 2009

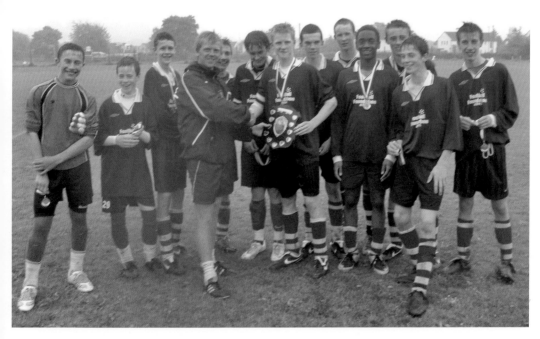

39 Year 10 football finals, 2009.

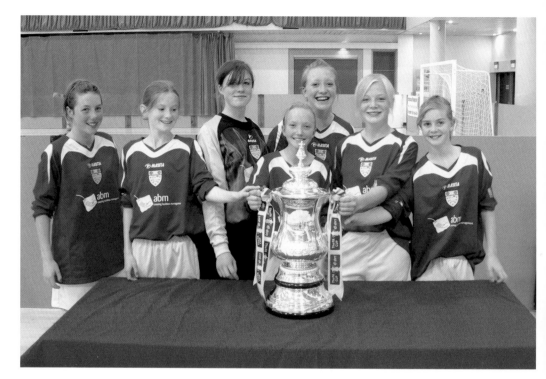

40 Girls football, July 2006.

41 Netball PGL Tour, 2009.

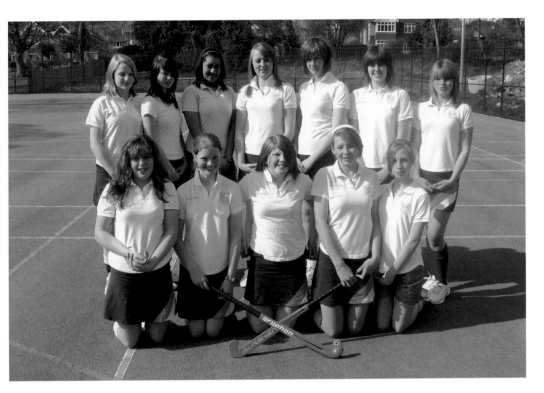

42 Girls hockey, 2009.

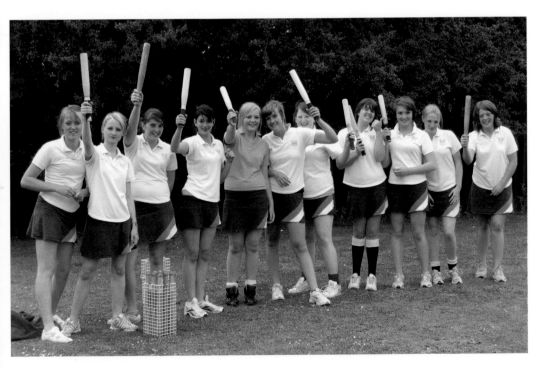

43 Girls rounders, 2009.

44 High jump – Prince of Wales Stadium inter-schools athletics meeting, 2009.

45 Javelin – Prince of Wales Stadium inter-schools athletics meeting, 2009.

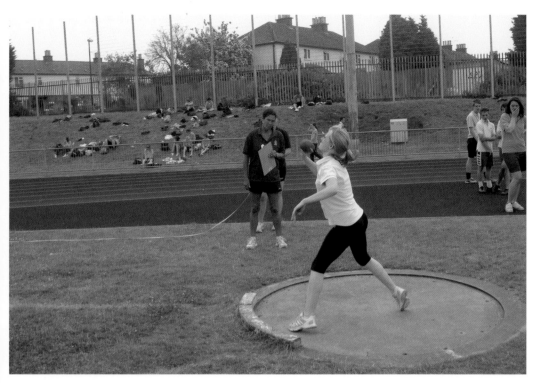

46 Shot put – Prince of Wales Stadium inter-schools athletics meeting, 2009.

47 Relay race – Rednock Sports Day, 2005.

48 Long jump – Rednock Sports Day, 2005.

49 Basketball, 2006.

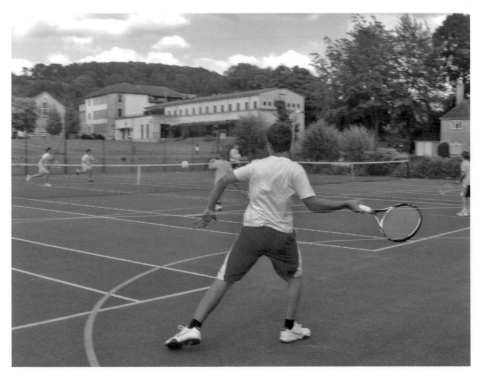

50 Tennis –Year 9 and 10, 2009.

51 Year 7 Geography – Study of Cheddar, 2006.

52 Geography – River Cole Fieldwork, 2008.

53 & 54 Geography – Year 8 coastal study trip, 2008.

History

55, 56 & 57
Living History Day
at Berkeley Castle
1993, involving
Small Schools
Cluster (Primary)
and Rednock
students.

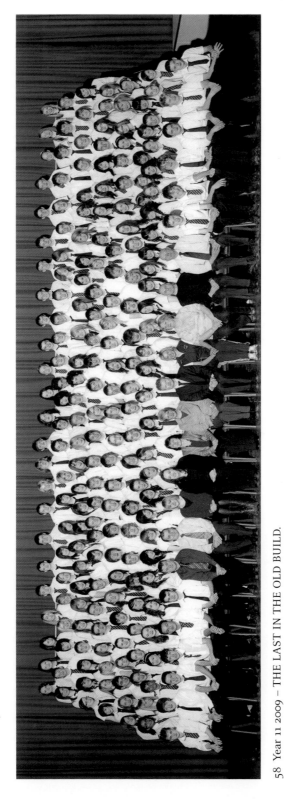

58 Year 11 2009 – THE LAST IN THE OLD BUILD.
With teachers (front row) Chris Teague, Andy MacDonald, Jenny Newbold, Dawn Allen, Jayne Harrison (Year Skills Co-ordinator),
Alison Bagnall (Year Co-ordinator), John Davis (Deputy Headteacher), Hannah Lloyd, Karen Rushton, Richard Brown, Bill MacKenzie.

59 2008 view of the three-storey building housing the Art, Food Technology and English departments. Also partly visible are the Science Block, Library and the Bob Cotton memorial stone.

60 Front view of the new Rednock School building at the start of the new school year on 7 September 2009.